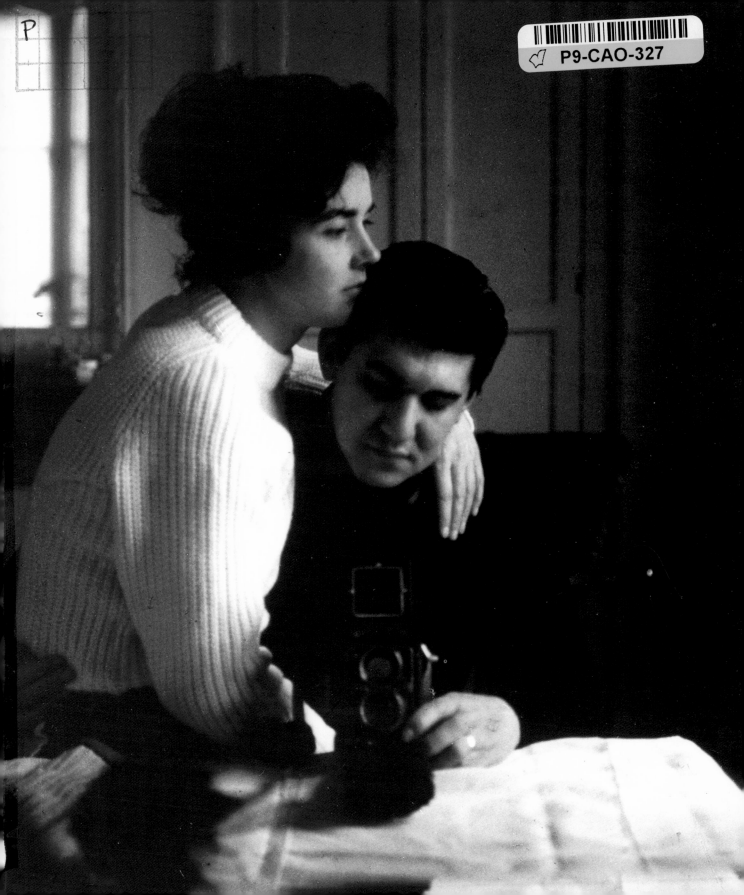

# LEWIS MORLEY

LEWIS MORLEY
7 July – 10 September 2006
Art Gallery of New South Wales

Published by the Art Gallery of New South Wales
Art Gallery Road, The Domain, Sydney, Australia
www.artgallery.nsw.gov.au

## Cataloguing-in-publication data
Morley, Lewis.
Lewis Morley.
Lewis Morley interviewed by Judy Annear.
Essay by Barry Humphries.
Catalogue of an exhibition held at the
Art Gallery of New South Wales, Sydney,
7th July – 10th September 2006.
Includes bibliographical references.
ISBN 0 7347 6393 X
ISBN 978 0 7347 6393 8
1. Morley, Lewis–Exhibitions.
2. Morley, Lewis–Interviews.
3. Photography, Artistic–Exhibitions.
I. Annear, Judy. II. Humphries, Barry.
III. Art Gallery of New South Wales. IV. Title.

The Art Gallery of New South Wales is a statutory
body of the NSW state government

## Acknowledgments
Louise Fischer
David Knaus
Julie Lambert
Ewen McDonald
Lewis and Pat Morley
Art Gallery of New South Wales Research Library
Exhibitions branch, State Library of New South Wales
Museum of Contemporary Art, Sydney

Curator and editor: Judy Annear
Exhibition manager: Anne Flanagan
Research: Anna Ridley
Registration: Charlotte Cox
Catalogue design: Karen Hancock
Production: Cara Hickman
Text editing: Jennifer Blunden
Photography: Chilin Gieng, Diana Panuccio
Prepress: Spitting Image, Sydney
Printing: Everbest Printing, China

All works © Lewis Morley unless otherwise stated

cover: **At the Cavern nightclub, Liverpool** 1963 (detail)
gelatin silver photograph, 19.9 x 24.9 cm

back cover: **American sailors, Puerto Rico** 1962
gelatin silver photograph, 27.6 x 25.5 cm

p 1: **Self-portrait in a mirror with Pat, Paris** 1959
gelatin silver photograph, 27.8 x 26.2 cm

pp 122–23: **Alan Bennett, Peter Cook,
Jonathan Miller and Dudley Moore for**
*Beyond the fringe* publicity, London 1961 (detail)
gelatin silver photograph, 29.1 x 35.6 cm

p 124: **Garden at the Musée Rodin, Paris** 1985
gelatin silver photograph, 30.1 x 25.3 cm

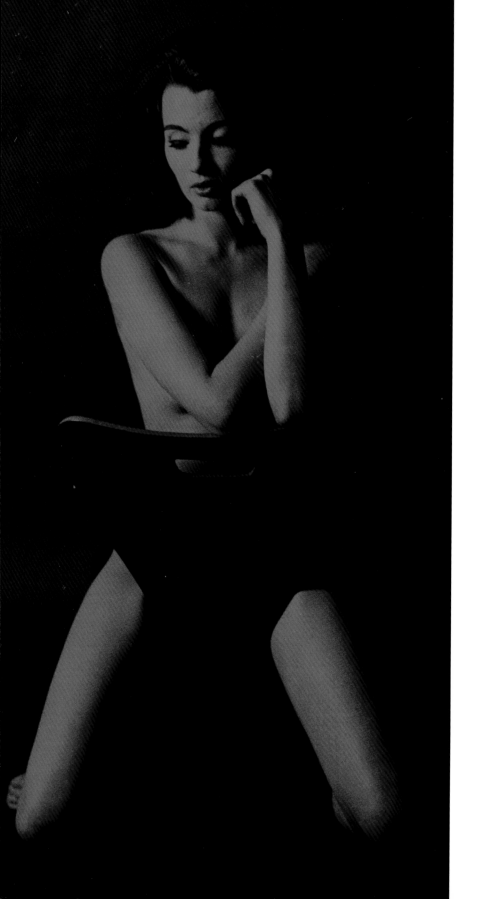

Christine Keeler, London 1963
gelatin silver photograph, aniline dye
43.5 x 22.3 cm

# Foreword

The 20th century was certainly one of unforgettable images which have defined its social, political and cultural history and stilled its moments both lasting and transitory. Without doubt one is Lewis Morley's 1963 photograph of Christine Keeler. It would be quite wrong to say that this image was his defining moment, but it surely was of the notorious yet I suspect strangely admired, perhaps even envied, Christine Keeler. It has always seemed to me typical of the enigmatic Morley that he, the elusive one, should have captured so many of the best-known faces of the second half of the 20th century, especially of the energetic and colourful London showbiz scene of the 60s.

Lewis may have made his name in the 60s but he did not rest his soul in that wonderful and anarchic decade. Witness his compelling 2003 image of the ever-intriguing Tracey Emin suspended in anxious bliss. Previous exhibitions of Morley's work have tended to concentrate on his portraits and images of 60s London but this exhibition seeks to be far more comprehensive, with nearly 150 works from a period of five decades. There is too, a wealth of archival and documentary material and thus an opportunity to see work that has been hitherto overlooked, or has lived in the shadow of those more familiar images.

I have always thought of Lewis Morley as a photographer of people, moreover of people poised, posed and craftily choreographed. But his instinct for that brief but unique moment travels with him wherever he and his camera go. Whilst we are accustomed to the staged, often quirky, poses of artists, actors and fashion plates of Lewis' oeuvre, this exhibition demonstrates his alertness to those decisive moments of life and activity which, so commonplace in our eyes, are so captivating to the artist's eye. *Bride in the rain, Hammersmith* 1957 may be reminiscent of Cartier-Bresson but Morley saw that moment of utter ordinariness and turned it into one of poignant beauty. It was also one of his earliest published images. His eye for composition, even one in which there is unusually for him an absence of people, is richly shown in the bleak but beautiful *Hampstead Heath* of more recent date, 1990.

It is high time that we are afforded the opportunity to see the more complete Lewis Morley because he has for too long been seen, and justly revered, as the chronicler of the figures and faces of 60s London alone. His images are wonderfully human, compellingly individual and always just that little bit unexpected. They are in all those qualities the perfect reflection of the man himself. A spirit of exuberance endures in his work as it does in him. We are greatly indebted to Lewis Morley for his involvement and cooperation in realising this exhibition, as we are to our curator Judy Annear with whom he worked so closely. It is an exhibition that celebrates a great rejuvenation of fashion, art, theatre, the media and even the beginnings of the dreaded cult of celebrity in postwar London, but it also celebrates the role and authority of the art of photography in seeing and recording our lives and times. To distil over five decades of Lewis Morley's prodigious work has been daunting for both Morley and Judy Annear. Our thanks to both of them and finally to Pat Morley, who has been muse, subject, companion and wife in Lewis Morley's colourful and much populated journey.

**Edmund Capon**
Director, Art Gallery of New South Wales

# Introduction

Lewis Morley's work spans more than 50 years and covers most genres of photography yet his activities depend upon two things – the found object and street photography. The confluence of these preoccupations makes him an unusual photographer. Regardless of whether his photographs can be defined as portraiture, theatre, reportage or fashion, there is invariably a sense of spontaneity in Morley's attention to a specific face, gesture or accidental conjunction of things. The same spontaneity also enlivens his work with inanimate objects, whether brought together for the camera or existing in time and space as assemblages. This exhibition of Morley's work provides examples of his best-known images alongside lesser known works. It includes substantial groupings of ephemera, contact sheets, publications and some objects to provide insights into Morley's way of working and the milieus in which he has worked – in London, Europe, Asia or Australia.

Although Morley had attended art schools both in England and in Paris between 1949 and 1953 and studied to be a painter, he found himself working in an advertising agency in London as an illustrator and later as a telephone operator to support his artistic ambitions. What he described as a flirtation with the camera from the late 1940s onwards became a full-on affair by 1957, when his first photographs were published in legendary photo editor Norman Hall's *Photography* magazine.[1] He was, in 1958, able to become a freelance full-time photographer.

The next few years must have been giddy as each new challenge landed on Morley's doorstep. The outsider with an English father and Chinese mother, who had been born and raised in Hong Kong and interned by the Japanese for four years during World War II, had found his feet in London in his early 30s. Morley was taking portrait photographs for *Tatler* magazine, fashion for *She* and *Go!*, and photographing theatre productions such as *Billy Liar* in an environment of social, political and creative change. The John Osborne play *Look back in anger* had opened in London in 1956, unleashing a new era in realist and critical English drama. Tony Armstrong-Jones photographed actor Alec Guinness in the play *Hotel Paradiso* that year as a grainy demented face – completely unlike the previous vogue for carefully posed and lit studio portraits. The Campaign for Nuclear Disarmament (CND) was formed in 1958, the year that also brought the march on Aldermaston (the headquarters of the United Kingdom's Atomic Weapons Establishment) and race riots in Notting Hill. The French *nouvelle vague* in cinema began in 1959 with the release of François Truffaut's *400 Blows*. In 1960 *Beyond the fringe*, the satirical review with Peter Cook, Dudley Moore, Jonathan Miller and Alan Bennett debuted at the Edinburgh Festival, and *Coronation Street* began its life on television. In 1961 Morley became involved with Peter Cook and Dudley Moore and The Establishment nightclub in Soho, *Private Eye* was launched, and Christine Keeler met John Profumo.[2] The British class structure appeared to be collapsing, lampooned on all sides. Being young, restless and radical was suddenly the most important thing to be.

London in the late 1950s and 1960s had a remarkable mix of photographers each breaking ground in their own way. These included Tony Armstrong-Jones, whose lyrical and energetic style moved beyond the studio to the streets and into the theatres; Don McCullin, a working-class boy who

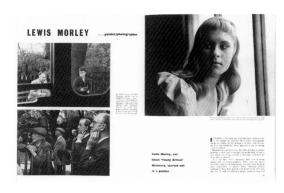

'Lewis Morley … painter, photographer'
*Photography* magazine Nov 1957
photographs by Lewis Morley
magazine, pp 30–31, 25.5 x 20.5 cm (closed)

photographed the ongoing poverty and violence of England for the *Observer* before tackling, in 1964, the horrors of war; and the new crop of fashion photographers such as David Bailey, who created celebrities out of criminals and fashion models alike.

Apart from Armstrong-Jones' theatre photography, which gave the genre a dynamism previously lacking, Morley's style and motives had more in common with older European photographers such as Henri Cartier-Bresson or Jacques-Henri Lartigue. Cartier-Bresson's viewpoint is often from slightly above, whereas Morley's is more likely to be from slightly below.[3] Cartier-Bresson emphasises the form of the subject in relation to its surroundings, while Morley's more intimate style highlights accidental and quirky gestures and glances. In 1976 Cartier-Bresson wrote: 'There are those who take photographs arranged beforehand and those who go out to discover the image to seize it. For me, the camera is a sketchbook, an instrument of intuition and spontaneity …'[4] While admiring aspects of Cartier-Bresson's work, Morley always eschewed his patrician rigour. The sheer joy of Lartigue's photography interested him more, the pure pleasure in celebrating a moment of life as it happens. There is no sense of *memento mori* here.

In an unpublished interview in 2003 Morley noted that in the 1950s he was also looking at Irving Penn's portraits because of their unusual locations and relaxed sitters, Richard Avedon's early fashion which was often outdoors, and John Deakin, who is now chiefly known for his compelling portraits of Francis Bacon.[5]

Morley's theatre photography began in 1959, when Lindsay Anderson invited him to do supporting work on *Sergeant Musgrave's dance*.[6] Armstrong-Jones was doing the main or front-of-house photography and was admired by Morley for having 'the courage to break away from the conventional formalised poses … [making him] the most exciting photographer that stepped on the English stage'.[7] Morley's interest in photographing actors in situ, unposed and with available light, resulted in dynamic images of Albert Finney, Anthony Hopkins, Zoë Caldwell, Peter O'Toole, Michael Caine, Trevor Howard, Michael Crawford, Maggie Smith, John Hurt, Warren Mitchell, Lynn Redgrave and Nicol Williamson amongst a host of other emerging luminaries. The way in which Morley approached his subjects is played out in the contact sheets, which clearly show his working method and how he selected and cropped a specific image for greatest effect.

For Morley, his encounter with Moore, Cook, Bennett and Miller in 1961 marked a further turning point. Taking the young *Beyond the fringe* satirists to Brighton Beach or the London Zoo, he let them 'ramble about'. These would be the first publicity photographs of performers which had nothing to do with what people saw on stage. Morley wanted something offbeat and this he achieved as he posed the revue-ists in front of a black-and-white striped wall and in the mouth of a large stormwater pipe. Morley photographed the *Fringe* boys on and off stage and on their various individual and collective endeavours. The advent of *Private Eye* magazine allowed Morley to contribute photographs for collages created by the editors which lampooned the British establishment. *That was the week that was*, the wildly successful satirical television comedy, gave Morley further scope as the principal photographer. The show captured an audience of 12 million viewers and rebounded in record and book form.

Christine Keeler 1963
contact sheet, 20.7 x 29.1 cm

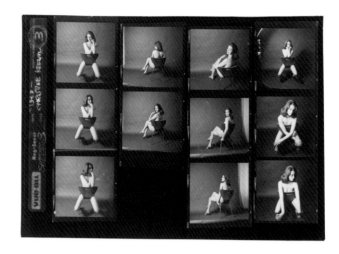

Morley's studio above Peter Cook's The Establishment nightclub had a river of models, actors, musicians, editors and journalists running through it – even after he moved to the top floor. In 1963 Christine Keeler was brought to him, ostensibly for promotional shots for a forthcoming film. Her name had been in the press since the previous year after revelations of her affairs with British minister for war John Profumo and Soviet military attaché Eugene Ivanov. It was the height of the Cold War: the Cuban missile crisis in 1962 had brought the world close to nuclear annihilation, and in 1963 British intelligence officer Kim Philby defected to the Soviet Union.

Morley's photograph of Keeler, apparently naked, straddling a cheap Swedish copy of Arne Jacobsen's famous chair has become an icon of 20th-century photography. Why this is so and how this photograph fits into Morley's oeuvre is interesting to consider. Morley has written in detail about the shoot and the remarkable life of this image in his autobiography.[8] Others have extensively analysed it, most notably David Mellor, who compares it to Edouard Manet's radical painting Olympia of exactly 100 years earlier.[9] Keeler, writes Mellor, 'steadfastly… returns the onlooker's gaze during the media carnival surrounding her – (a carnival which simultaneously abused, demonised and celebrated her) … Morley presented Keeler as if on a stage, in cabaret, but with her body abstracted, made both modest and titillating by her pose …' The fuss over this image, which continues to fascinate more than 40 years after it was made, is not dissimilar to the uproar that greeted Manet's Olympia. It was considered an outrage for a young woman to be painted nude as Olympia when her attributes were plainly those of a prostitute and she was gazing directly at the viewer. The shock of the iconic image of Keeler is that it is equally unapologetic.

The most well-known pose is deservedly so as much because of its aesthetic. The simplicity of form, the use of Morley's preferred warm-toned paper and the deep rich blacks from which Keeler's pale skin emerges are as timeless as they are sensual. Studying the contact sheets from the shoot, it is possible to see how much work in the darkroom Morley has put into this image in order to make it what it is. The other, red, Keeler in this exhibition looks down (Morley made a few prints in 1965 which he cropped vertically and stained with aniline dyes in primary colours). Its verticality enhances the X shape of her legs and chair back, further abstracting her body. Raised high on the tide of momentous political events and changing social mores that came to symbolise the 1960s, the photographs of Christine Keeler took on a new lease of life in 1989 with the release of a film about the Profumo affair entitled Scandal. They endure to such an extent that they are now synonymous with the very notion of cheeky celebrity, and everyone from Andrew Denton to Homer Simpson has straddled a chair in a similar pose.

Morley's capacity to transcend the mundane in his depictions of the human body produces a timeless quality in many of his photographs. These include playwright Joe Orton, artist Pauline Boty and Patricia Morley, all of whom are depicted classically – Boty full of exuberance and delight; Orton the sensual and moody pin-up boy; Patricia Morley being admired by her husband as she leans over a basin to wash her hair.

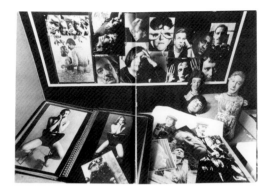

'Self-portrait' for *Pol*, autumn 1975
photograph by Lewis Morley
magazine, 31.5 x 23 cm (closed)
Courtesy *Pol* magazine

Morley's earliest portraits, from the late 1940s, are of himself or of his future wife Patricia. These intimate works were the beginnings of a substantial portfolio. Unlike Alfred Stieglitz' obsessive photographs of every detail of Georgia O'Keeffe's face and figure, these portraits of a relationship have a certain tentativeness imbued with grace. The earliest double portrait of photographer and wife is from 1959. Neither subject looks to the viewer and consequently both seem lost in thought. The circular composition of faces, hands, camera, light and dark is described elsewhere.[10] A later double portrait from the mid 1980s is dynamic with the angle of Patricia Morley's elbow echoed in the flash of light in the mirror. Lewis is reflected there as a dark and dramatic figure, tensing to take the shot.

Morley's self-portrait from 1977 is a striking image with distorted torso, angular arms and face hidden by the camera. That he has chosen to print this with the sprockets and edges of the film as part of the finished photograph reveals a sense of self, in this particular instance, as camera. A few years later Morley photographed himself as part of an assemblage, his head on a doll's body. This harks back to an earlier self-portrait which was reproduced in *Pol* magazine.[11] There Morley looks out from a foreground and backdrop comprised of his best-known photographs.

Portraiture in painting and photography retains an ongoing popularity as its audience continues to enjoy the opportunity to gaze at the famous and not so famous made static by either medium. The genre is easily made mundane and unfulfilling, but in Morley's hands portraiture, as with his theatre work, is often dynamic and performative. Jude Kuring nude in her

studio, Dudley Moore as fairy queen, Kenneth Horne in a rubbish tin, actor Victor Spinetti overwhelmed by a gigantic statue of a dead soldier, 1970s pop group Sherbet nude with and without bubbles, Lloyd Rees and his environment merging into the painterly mark, Helen Glad 'dressed' in her grandfather Norman Lindsay's nudes, Christo packaged ... Morley's inventiveness with portraiture blends into his work with found objects as is clear from his response to Christo. Morley shot Christo in his New York studio for *Belle* and subsequently wrapped the photograph and put it in a box. This straightforward response is echoed in Morley's portrait of Tracey Emin, where he has coloured the image, printed it onto canvas and attached elements which relate to her. In taking elements emblematic of an artist's personality, Morley acknowledges the time honoured, yet increasingly rare, mode of depicting a subject with selected attributes.[12]

The ease with which Morley worked in the studio and on the street made him an innovator in early 1960s fashion photography as did his frequent use of actors and unusual people as fashion models. Actresses Claire Bloom, Charlotte Rampling or Susannah York moved easily between fashion and stage in Morley's photography. Bobby Moore, captain of the English soccer team, posed for *She* bouncing his hat as though it were a ball. Such unpretentious and dynamic imagery was previously unheard of in the fashion world. Fashion had meant *haute couture* and depended upon a type of beauty or handsomeness which was not found on the street. Twiggy, on the other hand, was very much found on the street, carrying a brown paper parcel and accompanied by her boyfriend/manager

'What people are wearing'
*London Life* 8–12 Jan 1965
Susannah York and Twiggy
photographs by Lewis Morley
tearsheet, p 23, 31.5 x 23.9 cm
Courtesy Condé Nast Publications Ltd

'The friendship industry',
*London Life*, 12 Feb 1966
photograph by Lewis Morley
magazine, n/p,
28.1 x 21.7 cm (closed)
Courtesy Condé Nast Publications Ltd

on one of Morley's impromptu photographic outings for *London Life*.[13] Intriguingly, the magazine published the least flattering image from the shoot. This was the year before she achieved national and international fame as the face of 1966.

At its best, Morley's fashion photography picked up on elements that highlighted an interplay between garments and the environment. In *Fashion, Paris* 1959–61 the clothes and the graffitied wall behind blend into each other. In *Jenny Boyd for She* 1965, the stripes of the skirt echo the ribs of the sides of beef. He also documented the advent of the mini skirt in 1963. Suddenly legs assumed an importance they had never had before and photographers used the opportunity to full advantage.[14] Later, as a fashion photographer for *Dolly* in Australia, Morley continued to use unconventional models such as actor Graeme Blundell, who had shot to fame in the 1973 movie *Alvin Purple*.

The drama added to Morley's portrait and fashion photography by quirky relations between subject and environment is also apparent in his reportage. Reportage as a term struggles for meaning in the 21st century: it is associated with photojournalism and at its simplest is the reporting of news or information of general interest. In 1957 Norman Hall published an impressive spread of Morley's early photographs in *Photography* magazine, including *Trainspotter* and *Regent's Park zoo*. Hall notes the 'effective piece of dual framing' in *Trainspotter* which 'makes this a better than usual commentary on the interest of youth and the not so youthful boredom'.[15] *Regent's Park zoo* is distinguished by a boy holding a peacock feather that echoes the curve of the giraffe's neck in the

background, as well as the odd conjunction of zookeeper, boy, centralising column and giraffe. In the heyday of pictorial magazines (for example *Life*, the English Sunday magazines such as the *Observer*, or innovative monthly magazines like *Nova*),[16] reportage gave photographers the opportunity to publish photostories or essays on topics of social, cultural or political note. Morley was commissioned to do any number of these for *Tatler*, *Woman's Mirror*, *Women's Own* and others.[17] But by the late 1970s the rise of television had effectively strangled magazine and newspaper reportage, leaving a photographer such as Morley to continue as he had begun in the 1950s, always alert to curious and moving details.

Morley's habits of observation kept him productive in reportage during commercial shoots around the world in the 1970s and 1980s. His attention was caught, for example, by a little girl walking past a street seller (*Dolls, Italy* 1970s). The dynamic between child, man, and dolls is uncanny despite the bright sunlight. The role of glance, gesture and similarity of form is evident from Morley's earliest photographs, for example *Rue de Rivoli, Paris* 1950s, where the elegant mother and her child retreating down the street are mirrored by the gypsy woman and baby. Both women wear clothes patterned with the same spots but only the turning child has noticed, linking the two together across socio-economic barriers. Later images such as those taken in India in 1977 depend for their curiousness on an effect of views through the picture plane rather than any notion of the exotic. The 1985 photographs taken in Paris at the Rodin Museum are subtly strange as humans echo Rodin's fascination with body parts and the garden appears to have

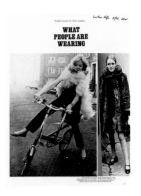

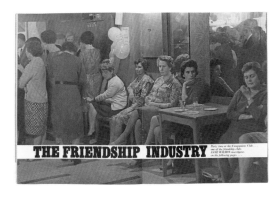

been invaded by an object from another world. Similarly in *Prague* 1992 a covered artefact in an alcove on a street causes the eye and mind to try to make sense of location, perspective and function but to little avail.

In the late 1950s and through the 1960s, however, Morley photographed the political ferment associated with the Cold War and the ever-present threat of a nuclear winter. The assessing glances of the businessmen in *Richmond station, Surrey* 1959, and the advent of stories in *Tatler* such as *Fairground faces* 1959 are revealing of the cracks in English social strata. Interestingly, Morley never followed the route of his peers, who adopted a hard grittiness to depict the times they were living in. While Morley could easily produce photographs such as *Cosy Café, Kings Road* … (late 1960s) or *Gorbals, Glasgow* 1964, he did not depend on the bleakness of the surroundings to deliver a message. Similarly his photographs of 1960s anti-war protests convey the energy of the moment and relationships between people rather than the horror that the protests were directed against.[18]

In 1965 Pathé Pictorial shot a short film on Morley as artist and photographer. Morley's interest in art, despite his success as a photographer, has never waned. His photography has been informed by his understanding of spatial relations, modelling and unusual conjunctions of objects. *Fossilised flower* 1980s and *Coco de mer and aubergine* 1994 are very literally still lifes arranged for the camera. The former is an absurdity as the fragility of the flower has been concretised and the latter is a specifically sexual play on the anthropomorphism of plants, with the massive feminine shape of the coco de mer dwarfing the shrivelled masculine form of the aubergine. An untitled still life from 1981 is an assemblage of objects posed for the camera and printed on paper treated with Liquid Light. The three-dimensional *Assemblage* made around the same time reveals more of Morley's interest in finding and placing objects. The most well-known exponent of assemblage is the American Joseph Cornell, whose mysterious boxes are dreamlike in their odd juxtapositions. Similarly Morley's work with found objects can be poetic in its arrangements, sometimes absurdist, and always dependent upon an emotional response to the nature of things.

For a photographer who established his name in the 1960s with photographs primarily of people, whether portraits, fashion, reportage or theatre, Morley's later work can seem increasingly ethereal and depopulated, for example, *Charles Bridge, Prague* 1992, *Japanese tombstone* 1993 and *Hampstead Heath, London* c1990. These enigmatic images of ambiguous and evanescent forms reveal made objects as inherently peculiar, obviating any need for interaction with people. However, his recent portraits are as inventive and lively as they ever were and Morley's delight in the world and its inhabitants continues unabated.

**Judy Annear**
Senior curator photography, Art Gallery of New South Wales

Prague 1992
gelatin silver photograph
31.6 x 21.4 cm

1 Norman Hall, 'Lewis Morley: painter/photographer', *Photography* Nov 1957, pp 30–35

2 See Hymie Dunn & Katherine Stout, 'Selected chronology: 1956-69' in *Art & the 60s: this was tomorrow*, Tate publishing, London 2004, pp 138–44

3 This is due to Morley's use of Hasselblad or Rollerflex cameras where one has to look down into the viewfinder from above

4 Henri Cartier-Bresson, *Aperture masters of photography number two: Henri Cartier-Bresson*, Aperture Foundation, New York 1976, p 7

5 Interview with Magda Keaney, National Portrait Gallery, Canberra, autumn 2003

6 The John Arden play that Anderson was directing

7 Lewis Morley, *Plays and Players*, July 1963, p 15

8 *Morley* 1992, pp 56–63 and see also www.vam.ac.uk/collections/photography/past_exhns/seeing/modern_icon

9 David Mellor, *The sixties art scene in London*, Barbican Art Gallery, London 1993, pp 135–36

10 Magda Keaney, *Lewis Morley: myself and eye*, National Portrait Gallery, Canberra 2003, unpaginated

11 Autumn 1975, pp 152–53

12 Another version of the portrait of Emin is included in this exhibition

13 This kind of talent spotting fashion photography all but disappeared until resurrected in the 1990s by Shoichi Aoki in Tokyo with his street magazine *Fruits* (1997–2002)

14 See David Mellor, 'Scandalous bodies' in *Lewis Morley: photographer of the sixties*, National Portrait Gallery, London 1989, p 24

15 Hall, *Photography*, p 30 and see also Keaney, *Lewis Morley: myself and eye*, unpaginated

16 *Nova* inspired Gareth Powell to set up *Pol* in Australia in 1968 and Morley photographed for *Pol* in the 1970s. See *Pol: portrait of a generation*, National Portrait Gallery, Canberra 2003

17 See especially the contact sheets and selected prints in this exhibition for the *Brian Epstein story* 1963

18 See David Mellor, 'Realism, satire, blow-ups: photography and the culture of social modernisation' in *Art & the 60s: this was tomorrow*, pp 69–73, especially the sections on urban realism and gothic horror

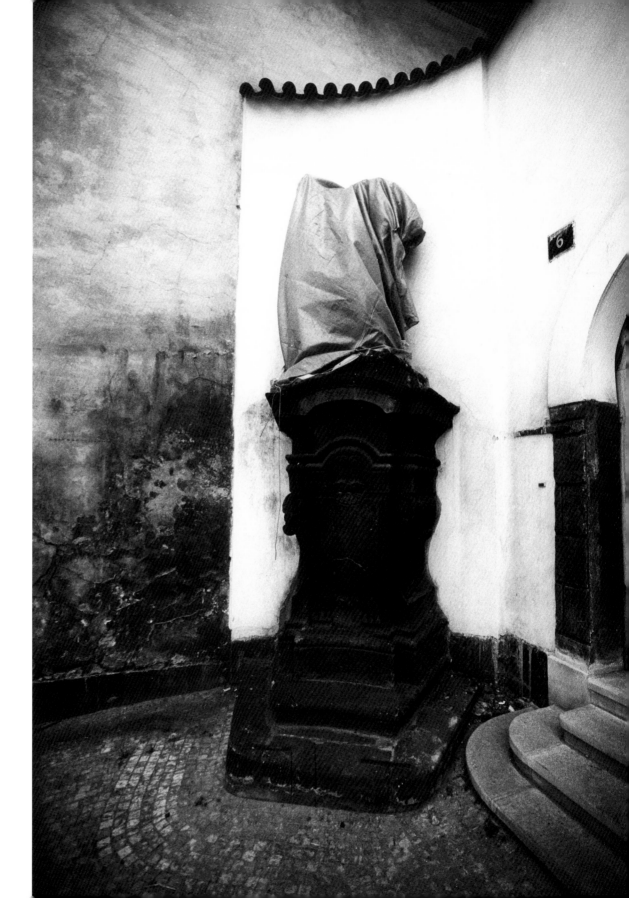

# Interview with Lewis Morley

Judy Annear

**Reportage is crucial to your work. How do you define reportage?**

Reportage was the type of photography I was most interested in during the 1950s because it wasn't an artform, it was a recording medium. Things could be recorded with a photograph more instantly than with other forms. Being a failed painter turned out to be a great asset; I could at least do something with the moment that I couldn't do in drawing or painting. Reportage was common in the days before television – people actually read photostories in magazines and newspapers. The advent of photography was a tremendous boost to people's knowledge of the world but now when people take photographs they tend to think in terms of selling them or exhibiting them, and they'll take any type of photograph which they'll then manipulate. I'm not saying that reportage isn't manipulated – it can be emotionally – but the thrill for me was having my photographs published. There were great reportage photographers and great photography as a form of recording. For me the greatest reportage photographer wasn't Henri Cartier-Bresson but Jacques-Henri Lartigue – he photographed from the heart.

**What was it with Cartier-Bresson and particularly Lartigue that you identified with?**

Early on I was familiar with and influenced by Cartier-Bresson but was unaware of Lartigue's photography until the late 1960s. When The Photographers Gallery in London showed Lartigue in 1971, I was knocked out by his work. The feeling with these two was that they had caught something as it was actually happening. I never felt that was the case with Robert Doisneau's work, and later I found out that what I thought were beautiful photographs were, in fact, all set ups. Reportage should be truly capturing a moment.

**What about reportage today? Have contemporary photographers working within this tradition lost sight of what 'the moment' actually is?**

Reportage has lost its way because television has taken over from the printed page. Live footage and news coverage are broadcast instantly. In the 1960s and 1970s you waited a week before a photograph came out but now, with digital cameras, images come out in the newspaper that same day or evening. And even though you've got speed with digitisation, people are more interested in seeing things actually happening in motion. Reportage is now confined to pretty pictures like those in *National Geographic* or to work like Salgado's, who does photographic essays on a particular environment or country which then come out as a book or exhibition. You don't see reportage in newspapers unless it's a war picture.

**In these early years did you look at Brassaï's photographs?**

Not so much. In the late 1950s, when I started being seriously interested in photography, the only place one saw pictures by Brassaï or other photographers was in the American magazines that came to England. The English magazines weren't even interested in people like Bill Brandt. There just wasn't much exposure to still photography until Norman Hall began editing

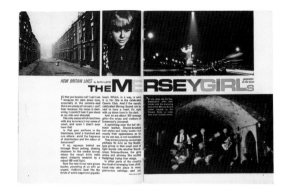

'The Mersey girls',
*Woman's Mirror*, 21 March 1964
photographs by Lewis Morley
magazine, pp 4–5
33 x 25.5 cm (closed)
Courtesy IPC Magazines, London

*Photography* magazine – he published photographers from around the world, especially Cartier-Bresson. The thing that really influenced me was *The family of man* exhibition when it came to London from New York in about 1956.

**Was it the type of imagery in *The family of man* or the radical, highly designed presentation that interested you?**
It was the first time photographs were presented in this manner. Here was this fantastic maze of large photographic blow-ups that you just wandered through. I was impressed by the immediacy of the images. Prior to that, photographs were exhibited on a wall, often with drapery around the bottom like Stieglitz' New York gallery 291 which opened in 1905 and was very secessionist in style.

**In the late 1940s and early 50s you went to art school and studied painting and drawing. Which painters interested you at that time?**
I was interested in both the old school – Tintoretto, Michelangelo, Leonardo for example – and in modern painting. I wasn't so interested in the impressionists but was knocked out by Braque and Picasso. I liked the facility of Picasso's line, but Braque was my mentor and favourite painter. There was this almost Oriental patterned, two-dimensional aspect in his work – very little sense of three dimensions.

**What about British painting in the 1950s and 60s?**
There was an early Francis Bacon in the Tate Gallery that I used to go and look at time and time again… a weird picture, a man sitting at a table. His *Pope Pius* series also intrigued

me but his late paintings made me feel a little uneasy. Early Lucien Freud paintings were so meticulously done that one thought, 'God, yes …' but now he too, is quite different. Then along came the 60s crowd, artists like John Bratby and Richard Smith who were influenced by 'kitchen sink' reality theatre. Painters and playwrights like John Osborne, Willis Hall and Keith Waterhouse, who wrote *Billy Liar*, focused on everyday life, eschewing the escapism of Noel Coward and others.

**In the foreword to your autobiography *Black and white lies*, Barry Humphries says that in the 1960s you saw everyone, 'whether from the world of theatre, literature, music or fashion with the detached eye of the outsider'. You frequently mention being an outsider. Is that due to growing up in Hong Kong and not actually living in England until you were in your 20s?**
I felt like an outsider for quite a few reasons, but the main one was being Eurasian. In England it wasn't such a stigma but in Hong Kong there was a hierarchy if you were from a mixed family. If your father was English and fairly high up on the social scale you were more accepted than if he was not. Fortunately, I went to a completely European school to start off with so I was only with Europeans. Then, when I got older, I had to go to a mixed school and the Eurasians had their own hierarchy. Arriving in England when I was 21 and then going into the RAF, I integrated quite easily. But the reason I became an outsider during the 1960s was more to do with my age – in that decade everyone else was in their early 20s

and I was already 35! I looked very young and behaved like them, but I didn't indulge in certain things just because they did. I never really liked drinking, so smoking became my habit. And I never willingly got into drugs – I always wanted to stay in control without outside help.

You have said that your intrinsic attitudes are very Chinese. What do you mean?
The main thing I think is loss of face: most Chinese will withstand torture but to lose face is shame making. It's the worst thing you can do to a Chinese person. I was brought up with my mother telling me that you've got to behave yourself because if you don't, people will say you're half Chinese and that's why you're the way you are. This led to me being not too ambitious – I felt that if I tripped up, I would lose face. With painting and drawing I wasn't all that good but with a camera I could easily achieve what I wanted, especially in the terms of reportage. And I wasn't one of those photographers who would wait for a photograph to happen. I'd just carry a camera with me and if a photograph happened it was because I was there. I'm more satisfied with a lesser picture if it truthfully captures the moment.

You've often said that you don't take photography too seriously, and that you have a love/hate relationship with it ...
When I say I don't take it seriously, I don't take it seriously for two reasons. Again, it's 'face': if I took it really seriously and got nowhere, I could lose face. The fact that I've got

where I have is truly by chance and being in the right place at the right time. But also it's because photography wasn't my true love, which was painting. When I worked in the theatre I saw the dedication people had, and I've never really been a dedicated person. That's what I mean about not taking photography seriously: I tend give up quite easily and take short cuts, though this has pluses too. Because I wasn't a properly trained photographer, I could say to art directors, well try this, and more often than not it would work. So I've always had a love/hate relationship with photography ... it's not that I hate it now, more that I love it less.

You've said your approach to photography is emotional. Can you elaborate on this and on how you know when something works or not?
Anybody can fry an egg, do a drawing and take a photograph. You can learn to use eggs and make a soufflé, which not everybody can. You can learn photography and make photographs which not everybody can do, but I have never gone through the process of learning except by my mistakes. I don't read books to find out. Now I'm not saying that studying won't make you a better photographer or painter, but there are some people who just are natural actors, photographers or painters in spite of what they think or do. I take photographs and they happen to be OK. I've taken photographs and thought, 'God, I wish this person was two inches more that way' but you have to take that chance. Sometimes it doesn't work so it doesn't work. I'm not a great still-life photographer because that would mean having to place things and that means you're

in charge. But if I see a still life in the street, a fallen branch with two stones – bang, I'll take it. Nature's done that but somehow I have the eye to be able to see it whereas other people would walk past. It's nothing to do with learning: it's just that certain people have certain gifts and the gift I had is that I could see things sometimes. I'm instinctively emotional … often it's the first thing that comes to mind and that's it. Maybe that's why I like the immediacy of photography.

*In a couple of self-portraits you're posed within a group of objects and in another, amid other photographs you've taken. They seem to have a close connection with the assemblages you've made. Were you aware of other artist's assemblages – Joseph Cornell's for example?*
When I first saw a Cornell assemblage I liked it so I kept an eye out for his work. Then I came across a lot of them and suddenly thought they were mundane. A few years later, I went back to them and thought they were alright after all. Cornell's work is quite intellectual, you have to ask yourself what it is you're looking at, whereas Robert Rauschenberg's assemblages are more emotional – they just hit you straight away. Then there's Morandi … I love the simplicity of Morandi. His etchings are not simple by any means; they're quite monumental. I also like Cecil Beaton's work tremendously – I think he's vastly underrated. Some pictures are so 'chi chi' but there are others which are superb. And in the 1950s many of us were influenced by John Deakin and the harshness of his work. Irving Penn was another who used harsh lighting but it was very refined; John Deakin wasn't refined at all.

*What about photographers like Don McCullin?*
All I saw at first was his war work, which I admired because he actually went into the fighting and photographed it. But I never liked Robert Capa – looking at a Capa war photograph doesn't affect me emotionally like a McCullin image. With McCullin, he's in there and he's taken it. Capa used to say if your picture isn't good, you're not close enough … but I always felt that Capa never got as close as Don McCullin.

*Returning to your portraits, despite what you've said about only taking self-portraits to use up a roll of film, you do take some very interesting ones – the way you contextualise yourself, use mirrors and the way you assemble objects around you, is an interesting extension of convention …*
I was being flippant – admitting to something then covering up. With a portrait, you photograph a person because either you've been commissioned to do it or because you see a person and just photograph them. The person hasn't much say either way. But if you're doing a self-portrait, you're doing it for yourself and consequently it's a bit of self indulgence – you don't have to do it. Some self-portraits were done after a session when there might be three or four frames left and I hate wasting those frames. I can do a self-portrait without thinking; you can do what you like and if it's a bad photograph, you don't have to share it. With a portrait of someone else, in spite of the fact that you photograph them your way, you still hope they'll like it.

*Your Tracey Emin portrait and Christo packaged go beyond the conventional. In the 1970s you photographed Christo in*

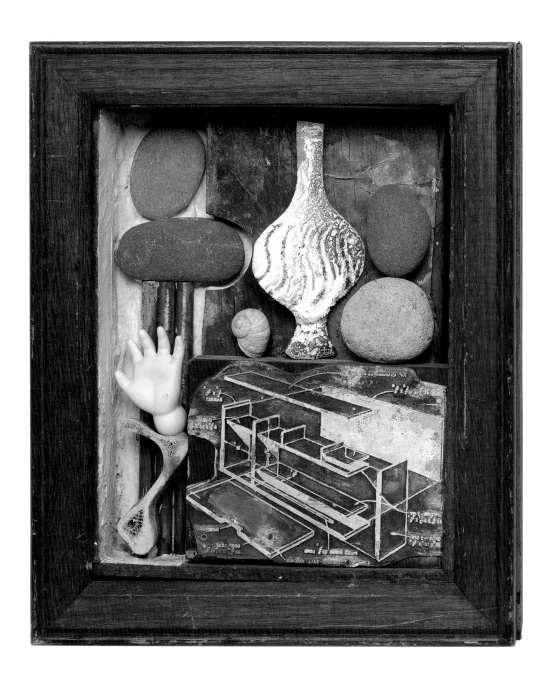

Assemblage 1980s
mixed media, 30.5 x 25.9 x 6.9 cm

New York and then you took that photograph and wrapped it up … the wrapping process is, of course, what Christo does. With the Tracey Emin piece, what did you do to the photograph?
I met Tracey through Beth Orton and took some photographs of her, just head and shoulder shots. One portrait looked quite good but it was a bit boring, so I blew it up to make it more interesting. I exposed the print and painted the face with developer, then splashed chemicals on the exposed parts, and where the developer didn't reach, the paper remained white. I fixed it and thought 'that looks great, rather abstract'. I did about 10 or 12 different backgrounds on the same portrait but splashing different parts. Her eyes were closed and I thought she looked dead. The black didn't look like blood so I painted the black red and coloured the face green to make her look even more dead. So I had this dead person with blood round her and I then remembered that embroidery was associated with her work so I thought, OK, I'll embroider 'Tracey Emin is alive and well' yet you are looking at someone who looks as if she's dead.

Tracey's rather contradictory too, and because she uses words – including four letter words – I thought I'd incorporate them as well. It becomes ambiguous then, 'Tracey is bloody alive', she's bloody and she's dead and 'fucking well', meaning she's not just well but she's fucking well. It's a sort of a pun. And a small picture wouldn't do, the image would only work if it was big. It's only recently that I've taken to doing big photographs digitally.

What motivated you to make *Christo packaged* an assemblage piece?
It was quite simple. I photographed him standing in his studio for *Belle* magazine and thought, well, he wraps everything so I'll wrap him. First I wrapped the photograph up and photographed it so there's nothing showing, then I tore holes in it to expose the image and then photographed it again. Once I'd torn it, it looked good so I put it in a perspex box and made it into a sculpture.

Let's talk about theatre. When did you start going to the theatre?
It began when I was in the RAF. I would come to London for the weekend and like all the troops go to the Nuffield Centre because we would have free tickets. I developed a love for theatre, especially dance, partly because my sister was a ballet dancer. Then when I was at art school I started going more and more. I saw the City of New York Ballet, the Roland Petit Ballet, and saw Erik Bruhn dance with the Royal Danish Ballet. And later I was asked to do theatre photography…

When did you first became aware of realist drama?
It was in the 1950s … reading about it and hearing critic Kenneth Tynan discuss John Osborne's seminal play *Look back in anger*. I didn't see the play but I saw another early Osborne play in 1958, *Epitaph for George Dillon*, that he wrote with Anthony Creighton. The acting and the writing impressed because it was so real. Around this time an American experimental group, The Living Theatre, toured England with

a play about drug dealing called *The connection*. This was followed by another American production, beat poet Michael McClure's 1965 play *The beard*. Later, when I went to America, I went to The Living Theatre and showed Judith Malina some of the photographs I had brought with me. She liked them, especially the photograph of Bertrand Russell at an anti-bomb rally. She said, 'It's a pity my husband Julian Beck isn't here, he's in hospital. He was in a demonstration and the police beat him up'. I ended up photographing some rehearsals at The Living Theatre and Judith Malina as well.

In a 1970s interview with Babette Hayes published in *Belle* magazine, you said that film was the medium of the age, not painting or sculpture or photography. Do you think film is still the medium?

After the war, when I came to England, I remember seeing the *Maxim Gorky Trilogy* directed by Mark Donskoy. Those three films knocked me out. Things happened in them that had happened to me. *My apprenticeship*, the second part of the trilogy, deals with the dignity of labour and people simply don't understand what that means. Only a couple of times have I burst into tears in the cinema. Once was watching this film, the other was *Pollock* directed by Ed Harris in 2000. In *My apprenticeship*, a boy who's in his late teens is with a group of people sitting around doing nothing. Suddenly a chap runs in and says the barge is sinking and there's stuff on it and they ought to get it out. They don't really care and amble off to pull this stuff out. Then suddenly they start working like mad to save what's on the barge. It's what happened to me in

the prison camp. The Japanese brought a whole pile of wood into the camp on a barge and we all had to carry the wood. Everyone picked the smallest piece to put on their shoulder. My friend and I thought, 'this is crazy, we'll have to do the bigger pieces later on'. So I decided to grab a large piece of wood and he did too – suddenly the other chaps all grabbed large pieces and soon everyone followed. Initially, it was 'who cares', but as we had to get the wood unloaded, there was this sudden surge of enthusiasm for the task and that film brought it out very well.

What was it about the film *Pollock*?

There was a sequence where the painter sits in front of this great big canvas and doesn't know what the hell to do. He stands up, gets his paint brush and goes whack. At that point I knew exactly how he felt. The tension being released with that slash of paint was amazing.

You started watching Truffaut in the 1950s?

It was 1962 with *Jules et Jim*. I found myself drawn to a lot of French films because they were more true to life, like *Casque d'Or*, the Jacques Becker film with Simone Signoret. These days I find films very hard to take when they are very explicit. It's like the off-stage scream: it's more terrifying than seeing something on stage. In *Casque d'Or* you saw the man and woman going to the bedroom and the next morning she's out in the garden and you know what's happened – you didn't have to be shown.

Do you still think that cinema is the art of now as you did in the 1970s?

Perhaps now art is going back to reportage, to documentary, to things that are actually happening. But with cinema, think of films like *Lord of the rings* – it's fantastic, especially the part of Gollum … it was something beyond my comprehension.

Do you think powerful images have become a kind of artform simply because they are so overpowering?
They're overpowering because you see what's actually happening. In the 1960s, *Life* magazine would do an article on, say, Hurricane Katrina by which time, a week or so later, everything would be over. *Time* magazine tried its best to get the information out within three days but we'd have already seen it on television. If we think of overpowering images in terms of modern reportage or as an artform, then I suppose catastrophes like the earthquake in Pakistan, the South Asian tsunami or the images of the Twin Towers being smashed are awesome … and you're just sitting there watching it all happen.

In *Black and white lies* you talk about the movie camera as a sentence and the still camera as a word. Is the medium of film as much as the apparatus also a sentence and is the single image also a word?
A sentence would say 'why don't you get off the chair and get out of the room' whereas the still photograph says 'piss off'. The same intention, but one is more immediate, more urgent. Quite often that one still image says so much more than a sequence on film. Think of the Hyunh Con Ut 1972 photo of the naked Vietnamese girl running down the road, or the 1968 Eddie Adams photograph of the death of a Vietcong soldier – single images have such great potency and impact.

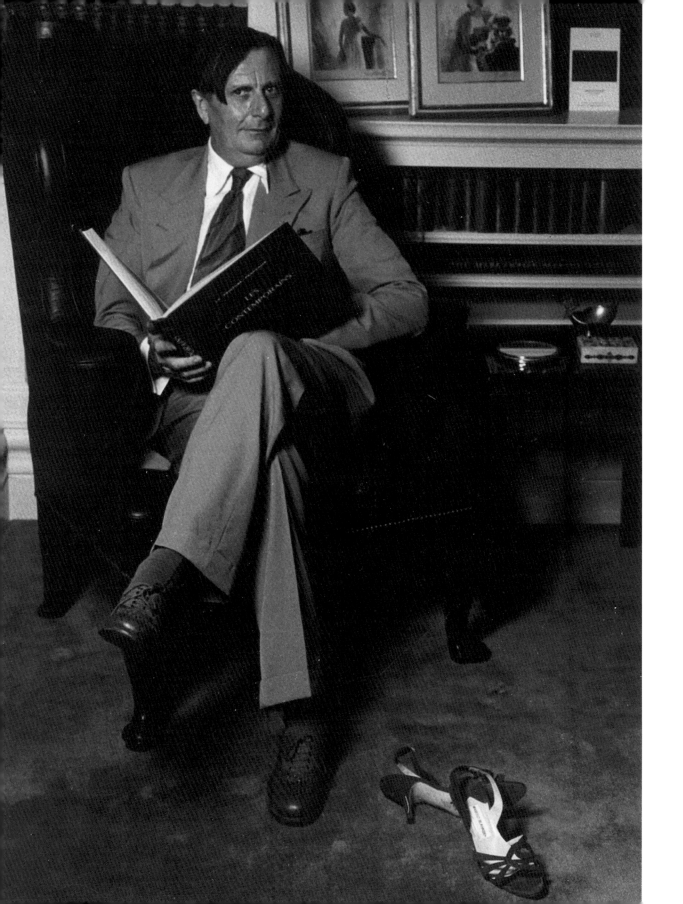

# Photographer of the age

Barry Humphries

It was in the offices of the long-defunct *Scene Magazine* in Greek Street, Soho, that I first met Lewis Morley. I had been booked a couple of months before in New York by Peter Cook, the comedian turned impresario, to perform at his new London club The Establishment. It was a rather overwhelming invitation and one I was less than confident that I could fulfil; after all, Peter only knew my work from listening to recordings made in Melbourne and London in the late 50s, but he seemed sufficiently confident in my ability to perform in cabaret in London's hottest new venue to pay me the astronomical sum of £100 a week. Only a year before, when I was in the cast of *Oliver* in the West End, I was earning a mere 20 quid.

Peter was in New York and I was in the hands of the club's young manager Nicholas Luard. 'We'll need some photographs of you to put outside the club', he said. I showed him a few stills I had had taken by a famous but old-fashioned theatrical photographer called Angus McBean when I first arrived in London. They made me look like a callow teenager and also imparted to me that pleading, importunate look so common in the photographs of actors. 'Will these do?' I asked. Luard flung them on the desk, 'No!' he exclaimed, 'We'll need something much more groovy than that' ('groovy' was the chief epithet of the decade). 'We'll get Lewis to take some new pictures', Nick declared, picking up a telephone.

I was rather unused to this kind of star treatment and it was not wholly disagreeable. 'His studio is just upstairs so get along there at 10 o'clock tomorrow morning'. At this point, I had absolutely no idea what I would do when I stood on that small stage at The Establishment. The little theatre restaurant had already been host to a number of brilliant young satirists with Oxford and Cambridge backgrounds. Their acts were all very political, irreverent by the anodyne standards of those days; and even a rather spotty Methodist minister's son called David Frost, whose monologue was not particularly hilarious, had brought down the house. That night in the French pub, a Soho hangout of artists, writers and 'groupies', I mentioned that I was to be photographed by Lewis Morley the next day. A truculent young man who seemed able to afford double whiskeys asked me aggressively why *he* wasn't taking my picture. 'What's that Chinese bastard doing muscling in on my job?' he growled, rather to my confusion. There had been some kind of misunderstanding and I was caught in the middle of it. Moreover, I didn't like this fellow in the pub one bit, though Jeffrey Barnard and I later became friends; but much later. This was not my first brush with an eccentric London photographer. I had recently given a £10 advance to a dubious Soho character called John Deakin, who had promised to take some professional pictures of me. He had taken a famous photograph of Dylan Thomas, and I later learnt that he took porno snaps for Francis Bacon for use in producing his large and unappetising canvases in which smudgy nude men did smudgy things on tripods and billiard tables. Deakin disappeared with my money and I never saw him again.

Next morning I met Lewis Morley who was, as he is today, immensely charming and reassuring. There had been a misapprehension about who was to be the official Establishment photographer and Barnard had, as usual, got hold of the wrong end of the stick with which he intended to beat me up anyway.

p 24
Barry Humphries on his
60th birthday, Sydney 1994
gelatin silver photograph
25.8 x 18.7 cm

For the photographic session I wore my new corduroy jacket with suede elbow patches bought in New York and, of course, a shirt and tie. In those far-off days I wore my hair very long, and smoked rather a lot. The most conspicuous things about the photographs Lewis took at the time are my hair, lank and none too clean-looking, and the inevitable fag. Of course, everyone smoked, it was groovy and in Soho one was meant to smoke Gauloises, which I noticed Lewis Morley smoked as well. He took a lot of pictures that morning in many of which, at his suggestion, I posed in an angular way rather like a skinny *saltimbanque* in a Picasso drawing of the blue period. Soon, a grainy enlargement of one of these was on exhibition outside the club in Greek Street.

Lewis Morley, whose hair was jet black and cut in a fringe like Foujita, always wore black. He was certainly tall, exotic and part of this new theatrical world that I had somehow gatecrashed. I little thought then that he would become such a central figure in the artistic life of the decade we had just entered, the 1960s.

My show, I'm afraid, was rather a flop. Perhaps that was inevitable since I could not make jokes about the prime minister Harold Macmillan or any of the other Aunt Sallies regularly rebuked by the satirists. My so-called act consisted of a shrill suburban monologue from the youthful Edna and a rambling rumination by Sandy Stone, which found little favour with the trendy Dolly Birds in their miniskirts and mascara or their groovy consorts. Lewis Morley's publicity photos were thereafter, no doubt, consigned to a file marked 'archive'.

Over the ten years that followed, Lewis and I met off and on and the next pictures he took of me were in more prosperous times, at the house I lived in with my wife and daughters in Little Venice, surrounded by the trophies of a modest success. There is still a cigarette drooping from my lips but when I look at all the other portraits that he took during those years, pretty well everyone is smoking.

At the end of the 60s I had a short vacation at Salamis in Cyprus with a girlfriend of considerable beauty. It was not an excursion I wished to advertise to the world so you may imagine my dismay in coming down to a late breakfast and bumping into Lewis Morley. I have no idea why he was there but he was tactful enough to ask no questions and took some very funny photographs of me in my white suit in front of an incurious camel.

It was many years before we met again, when I learnt, I think by accident, that he lived in an inner-suburb of Sydney (an Italian enclave) with his wife of over half a century, Patricia Clifford. Unlike other photographers, and most other people, Lewis is erudite on most subjects, a gifted artist and an authority on art and music. His collections of prints and drawings – English, French and German – are extraordinary and he knows a Wadsworth from a Nevinson at 30 paces. In the parlour of his house, surrounded by books and pictures, we reminisce endlessly, and perhaps occasionally to the boredom and exasperation of others present, about the people we knew. Hoping to stump him I often like to ask one of those 'whatever happened to so and so' questions, usually naming some forgotten comedian or extinguished starlet of the period. Invariably, Lewis not only knew, say, Imogene Hassell or Georgina Ward, but took her picture

as well, not to mention Salvador Dalí. He is however, modest to the point of self-effacement.

In the sixth decade of the 20th century there were several famous photographers, mostly Cockneys who rather thought of themselves as 'stars' – as far more important than their subjects. They all contributed to the history of fashion and as it later became called, 'lifestyle', and a couple of them are still going strong. On another plane, there was, of course, Cecil Beaton, whom I also knew and was photographed by, but Lewis Morley was, and is for me still, the quintessential photographer of the age. His lens does not merely record the appearance of things but is an instrument of his compassion and his intellectual curiosity. He is more interested in other people than himself. Lewis not only snapped people but he *knew* them, and mostly liked them as well, as anyone looking at his photographs will discern. Not to have been photographed by Lewis Morley is somehow not to have lived in the second half of the 20th century.

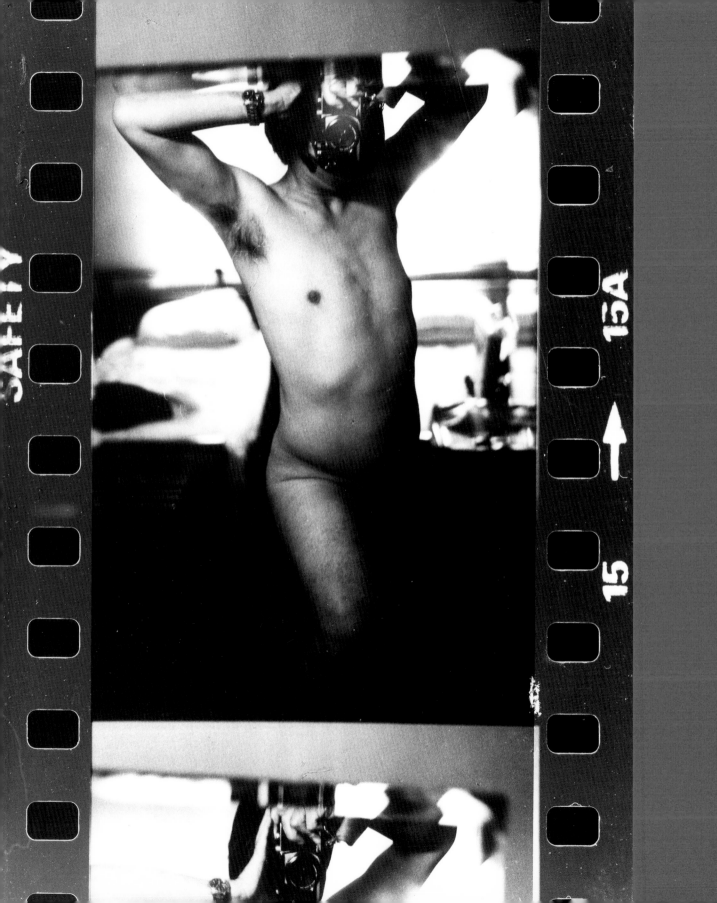

Self-portrait, Sri Lanka 1977
gelatin silver photograph, 30.9 x 23.1 cm    29

# Fashion

*Dolly* fashion, Sydney 1974
Cibachrome, 30.2 x 24.2 cm

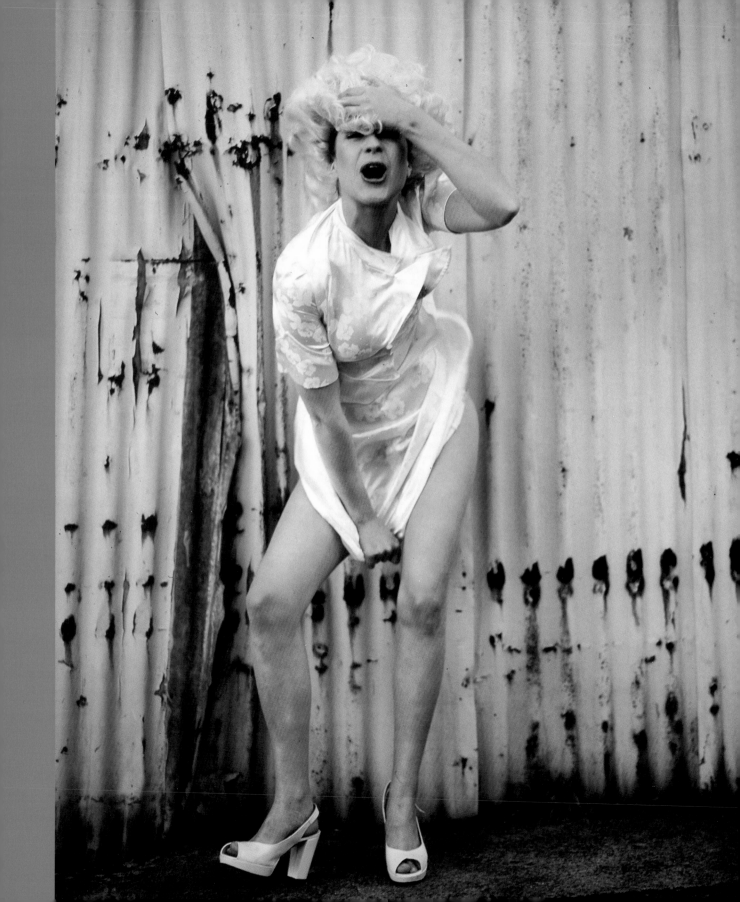

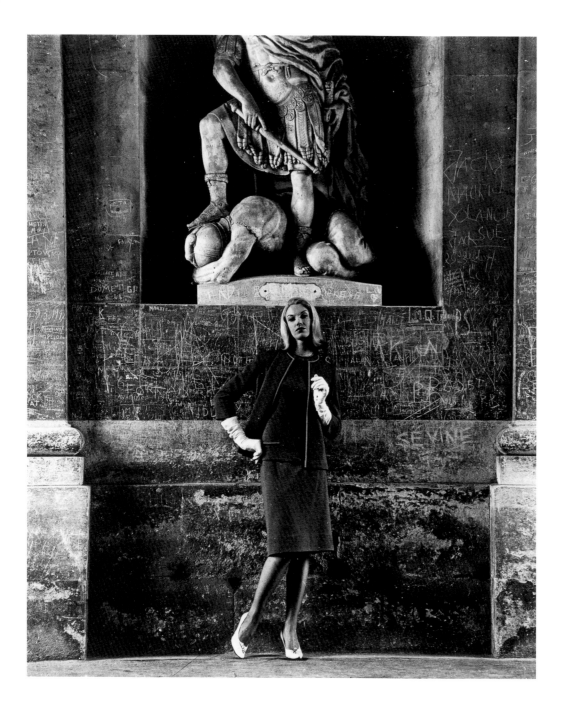

**Fashion, Paris** 1959–61
32    gelatin silver photograph, 28.7 x 23.5 cm

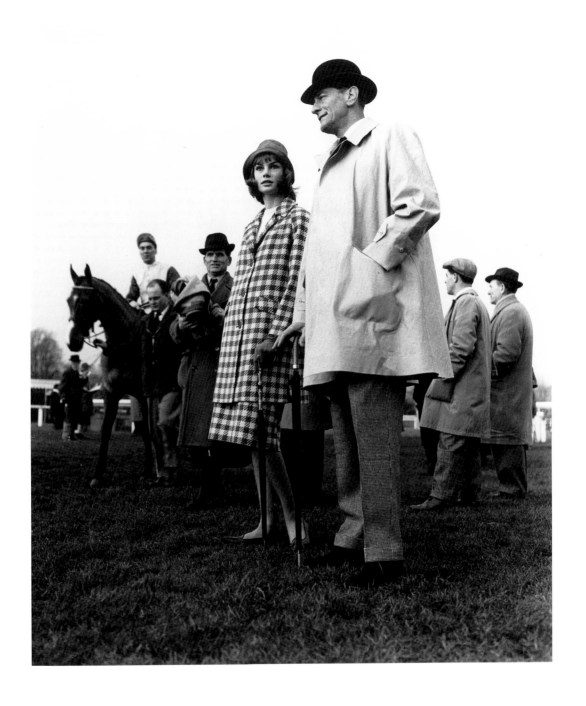

Jean Shrimpton and Chris Powell, racecourse fashion for *Go!* 1961
gelatin silver photograph, 31.4 x 26.8 cm    33

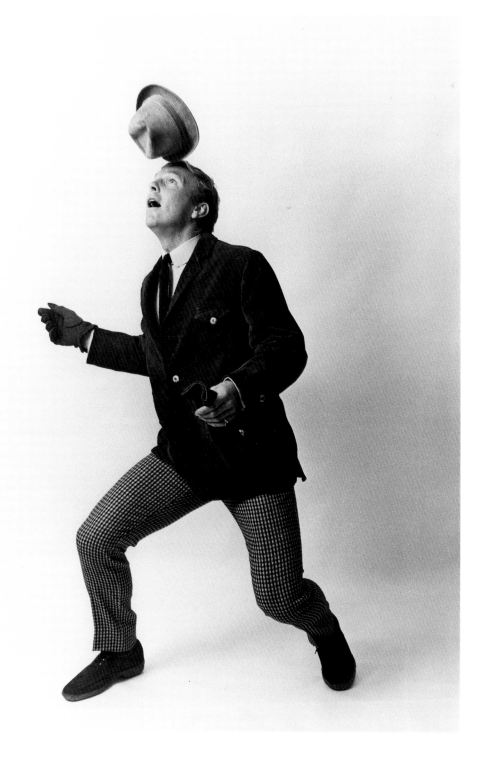

**Bobby Moore, captain of the English soccer team, London, for *She*** 1963–64
gelatin silver photograph, 44 x 30.4 cm. Courtesy National Magazine Company, London

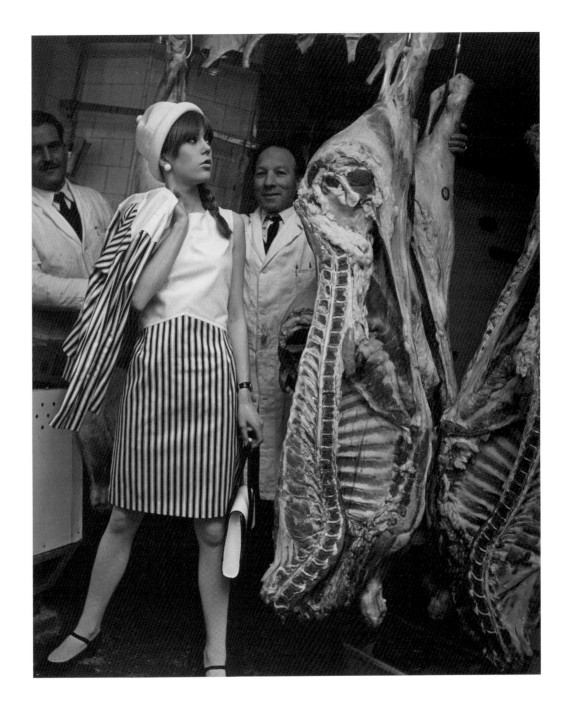

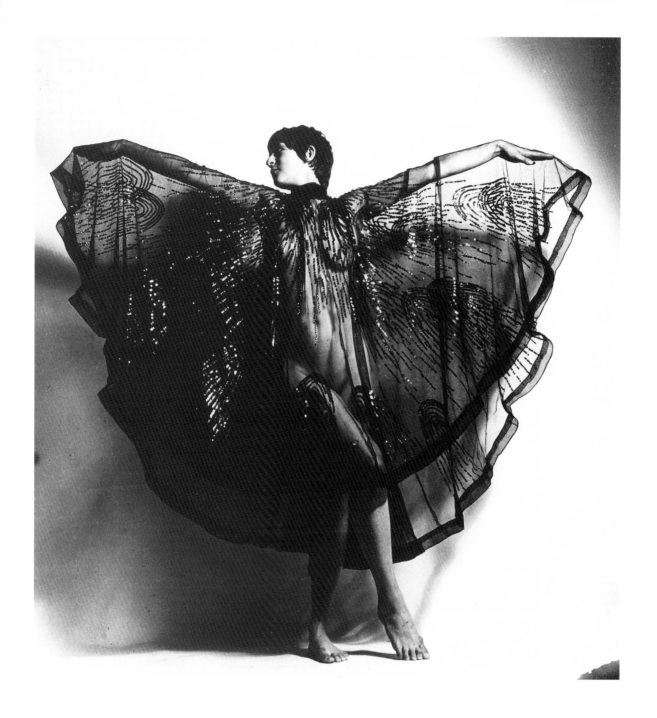

Mog Smith, fashion designer, London 1965
gelatin silver photograph, 27.3 x 25.8 cm

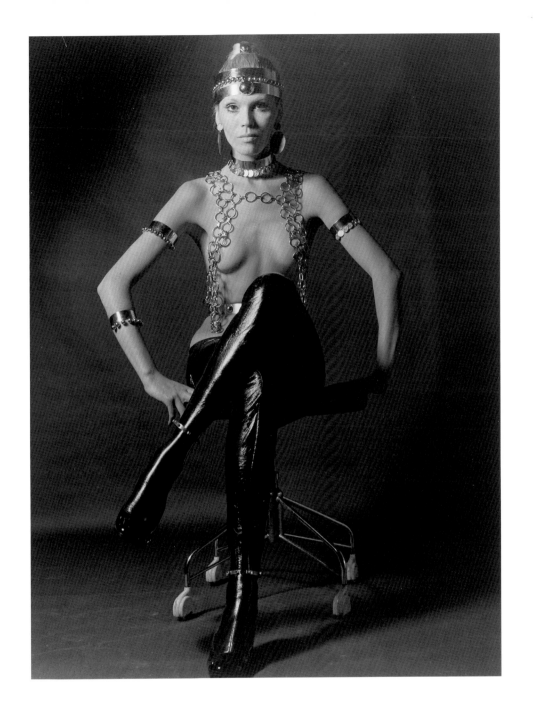

Chain-mail fashion for *She* 1969
gelatin silver photograph, 30.6 x 27.5 cm. Courtesy National Magazine Company, London    37

# Portraits

Dudley Moore as the Fairy Queen, Frith Street, London, for *Private Eye* 1963–64
gelatin silver photograph, 24.9 x 19.2 cm. Courtesy *Private Eye*, London

**Hussein Sheriff, painter, London** 1958
gelatin silver photograph, 25.2 x 32.6 cm

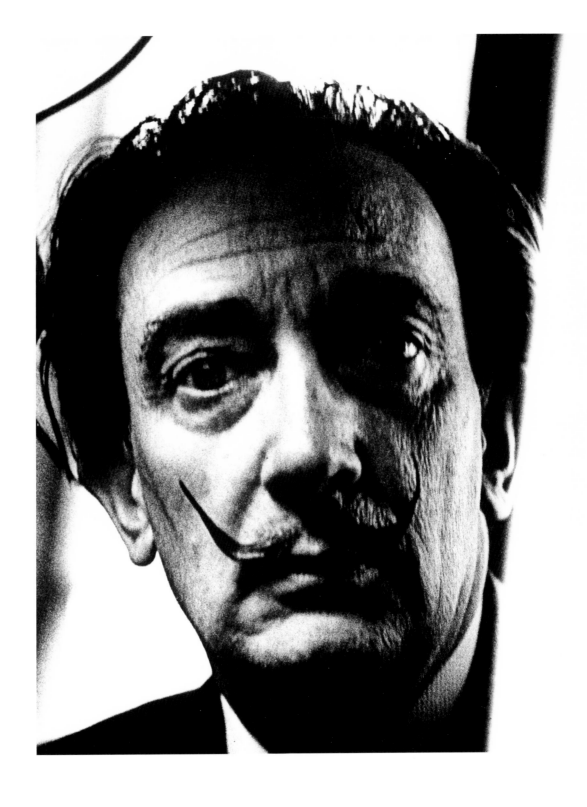

Salvador Dalí, London 1960
gelatin silver photograph, 50.5 x 40.5 cm    41

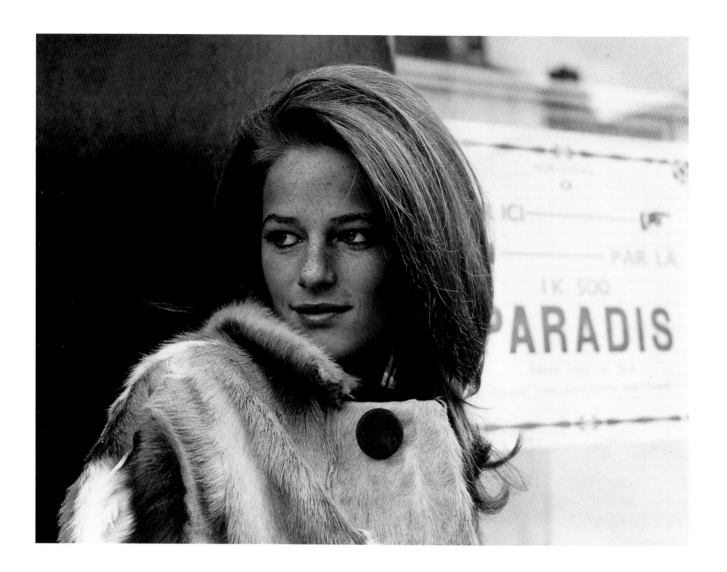

**Charlotte Rampling, London** early 1960s

gelatin silver photograph, 27.9 x 36.8 cm

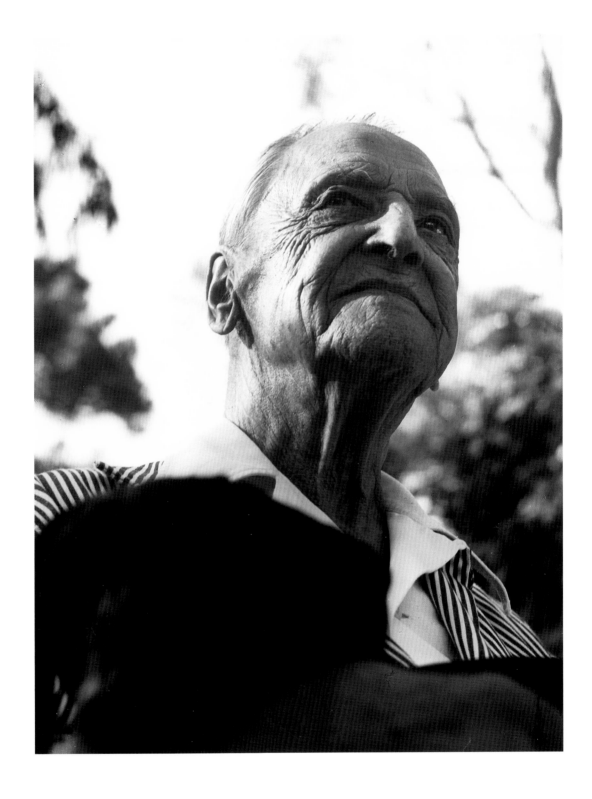

Somerset Maugham, San Tropez, France 1961
gelatin silver photograph, 36.7 x 27.9 cm    43

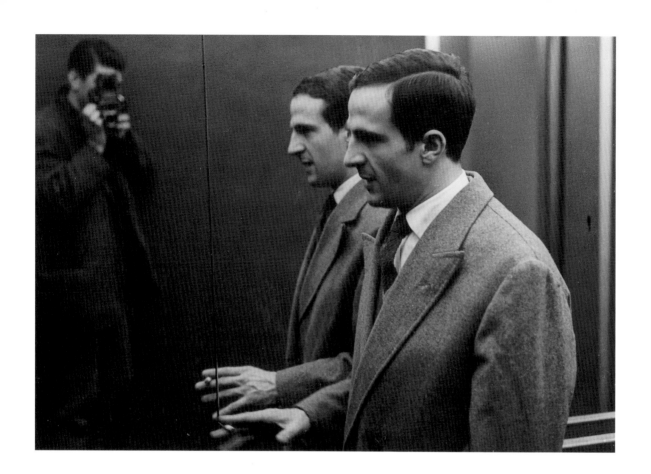

François Truffaut, London 1961
gelatin silver photograph, 12.3 x 17.6 cm

Terence Greer, playwright, outside Gare St Lazare, Paris 1962
gelatin silver photograph, 13.9 x 19.3 cm    45

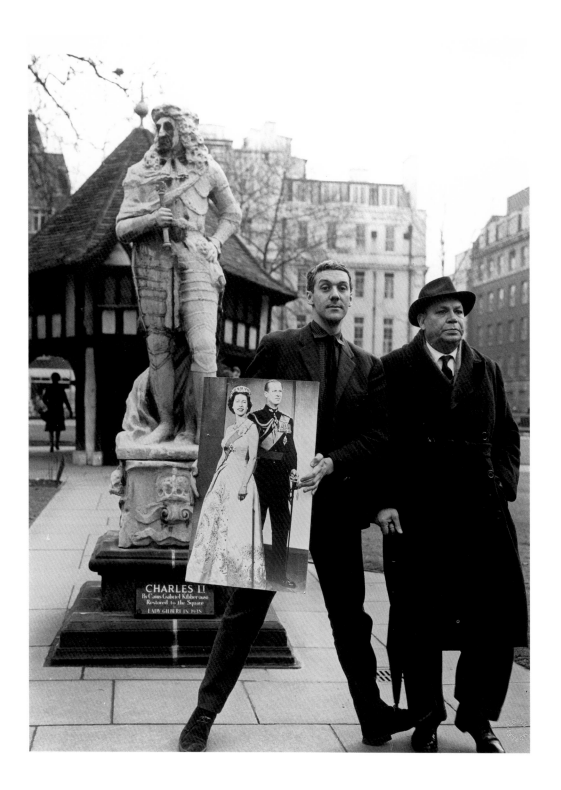

Roddy Maude Roxby, actor, Soho Square, London 1962
gelatin silver photograph, 38.8 x 29 cm

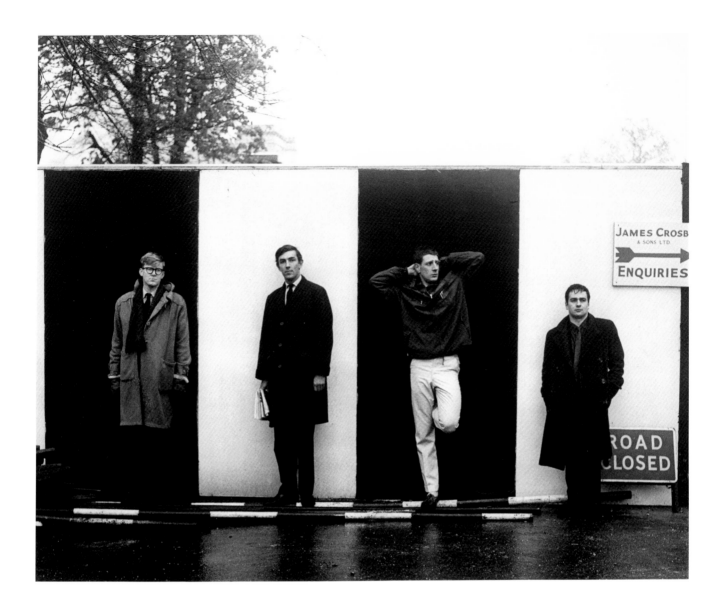

Alan Bennett, Peter Cook, Jonathan Miller and Dudley Moore for *Beyond the fringe* publicity, London 1961
gelatin silver photograph, 29.1 x 35.6 cm    47

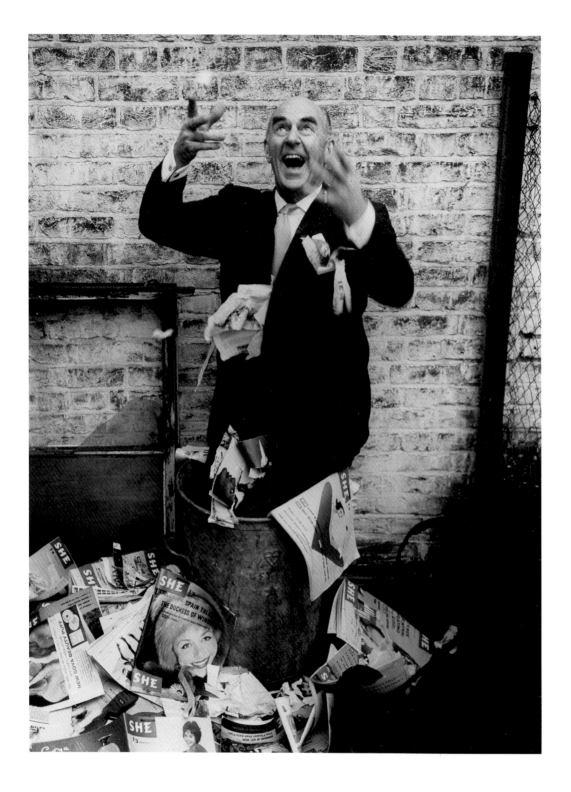

Kenneth Horne, art critic/comedian, for *She*, London mid 1960s

gelatin silver photograph, 39.8 x 29.4 cm. Courtesy National Magazine Company, London

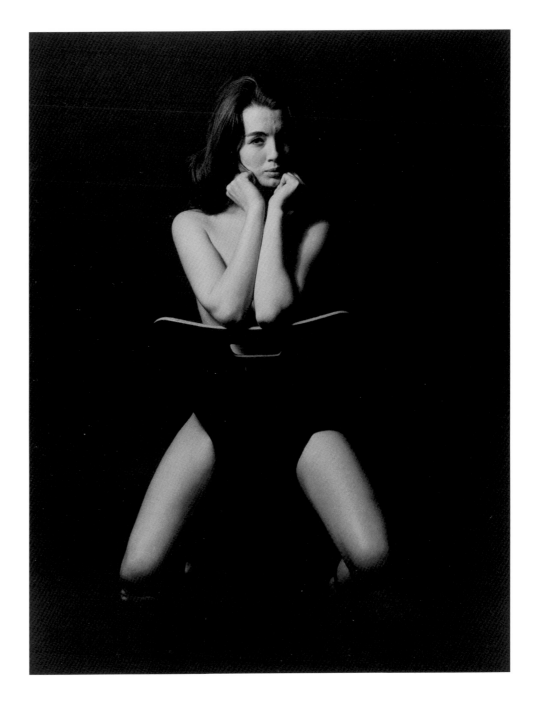

Christine Keeler, London 1963
gelatin silver photograph, 33.1 x 25.7 cm    49

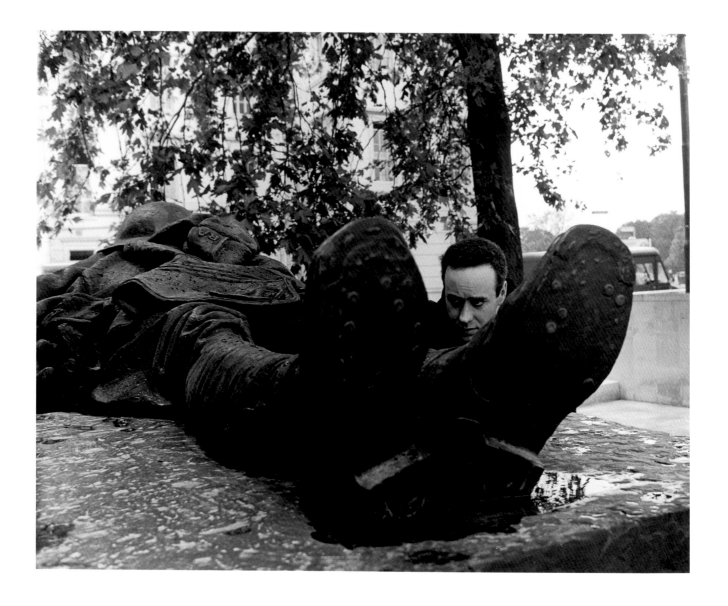

Victor Spinetti, War Memorial, Hyde Park, London, publicity shot for *Oh! what a lovely war* 1963

gelatin silver photograph, 40.6 x 50.6 cm

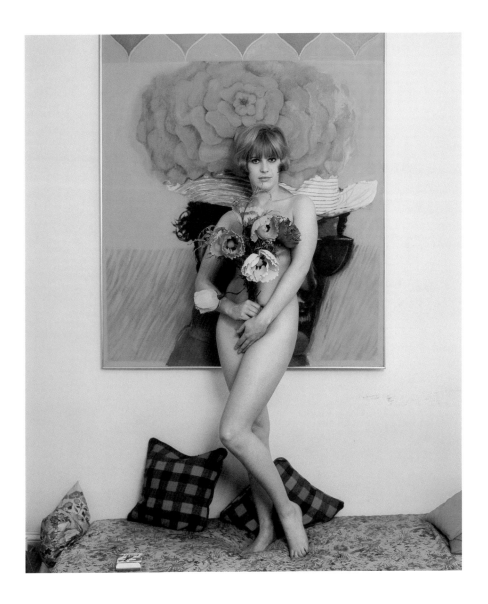

Pauline Boty, artist, London c1964
Cibachrome, 30.5 x 25.5 cm    51

André Previn, conductor/composer, Grosvenor Hotel, London c1965

gelatin silver photograph, 20.1 x 25.1 cm

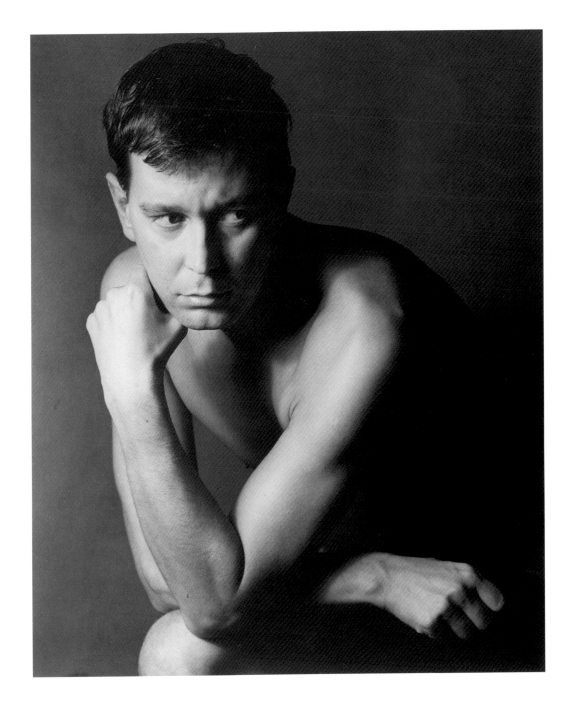

Joe Orton, playwright, London 1965
gelatin silver photograph, 35 x 28.8 cm    53

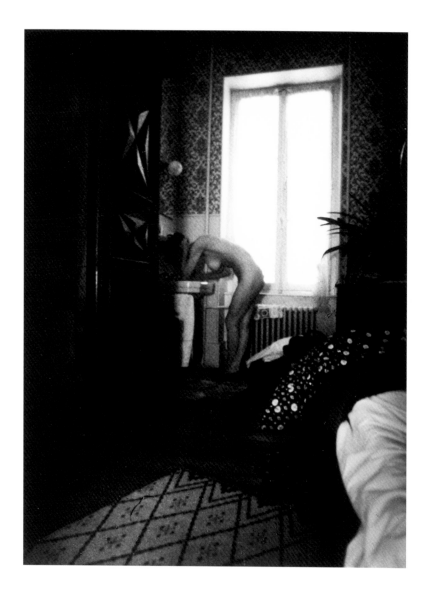

**Pat, Germany** late 1970s
54    gelatin silver photograph, 18.3 x 13.6 cm

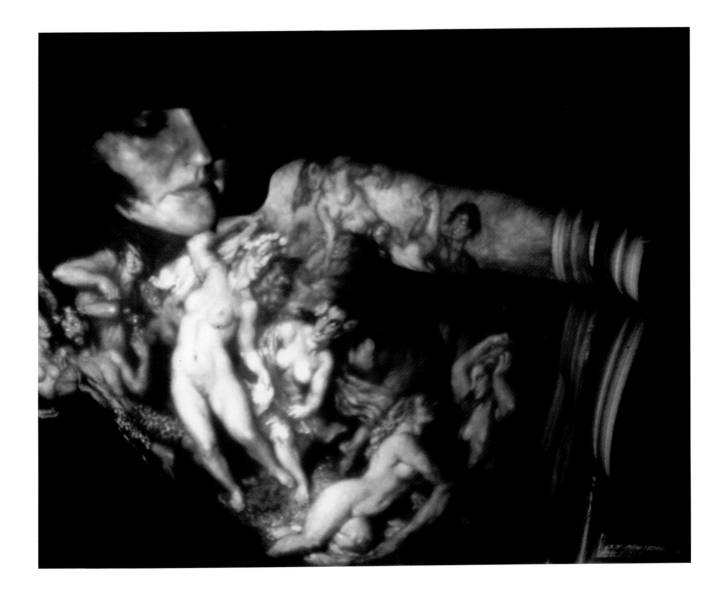

Helen Glad, Norman Lindsay's granddaughter, Sydney 1975
Cibachrome, 41 x 51 cm    55

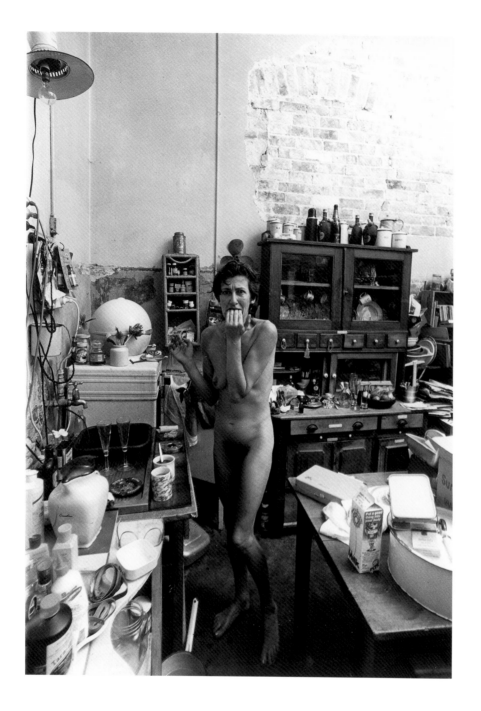

**Jude Kuring, artist, Sydney** early 1970s
gelatin silver photograph, 35.1 x 24.1 cm

Pat and self-portrait reflection, Sydney mid 1980s
gelatin silver photograph, 23.7 x 16.1 cm    57

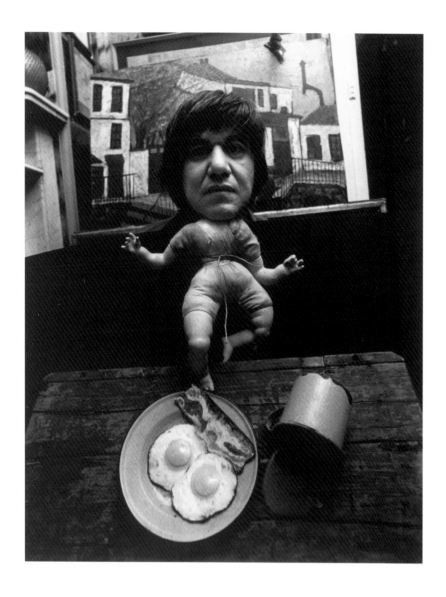

**Self-portrait with enamel bacon and eggs, Sydney** c1980
gelatin silver photograph, 30.2 x 23.6 cm

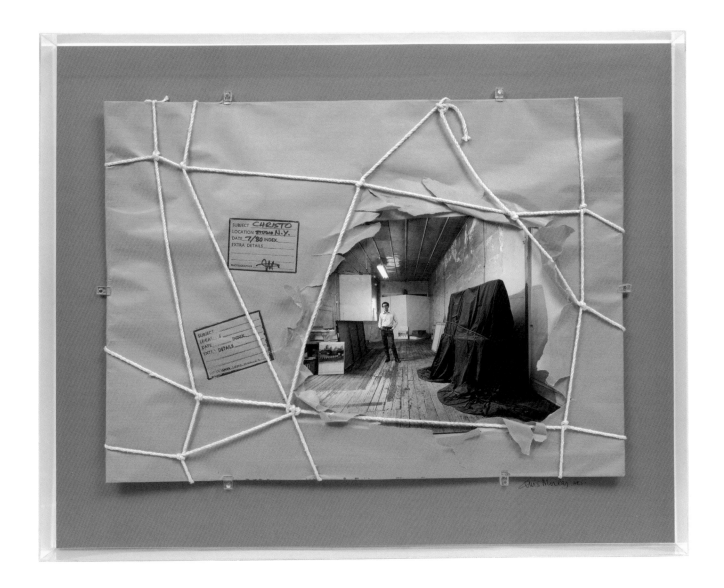

Christo wrapped 1980
gelatin silver photograph, paper, string, perspex box, 73 x 93 x 9.5 cm    59

Kerry Crowley, gallerist, 'Another time, another place, another chair', Sydney 1988
gelatin silver photograph, 29.9 x 40.3 cm

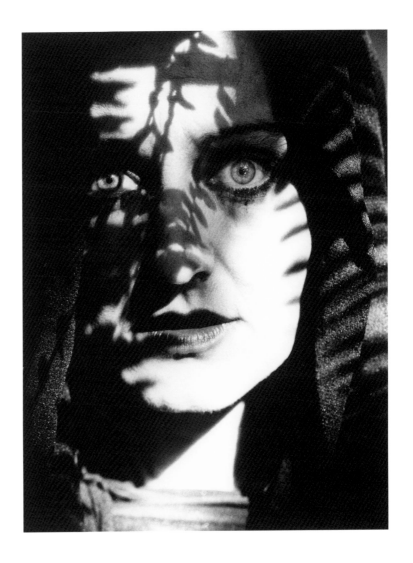

Wednesday Kennedy, actor, Sydney 1990
gelatin silver photograph, 28.1 x 21.2 cm    61

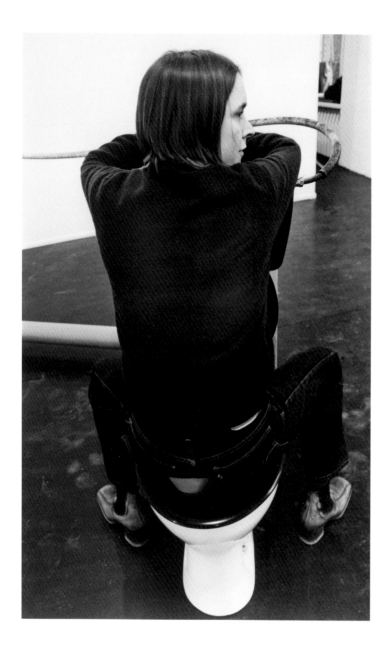

**Sarah Lucas, artist, Berlin** late 1990s
62   gelatin silver photograph, 30.6 x 19 cm

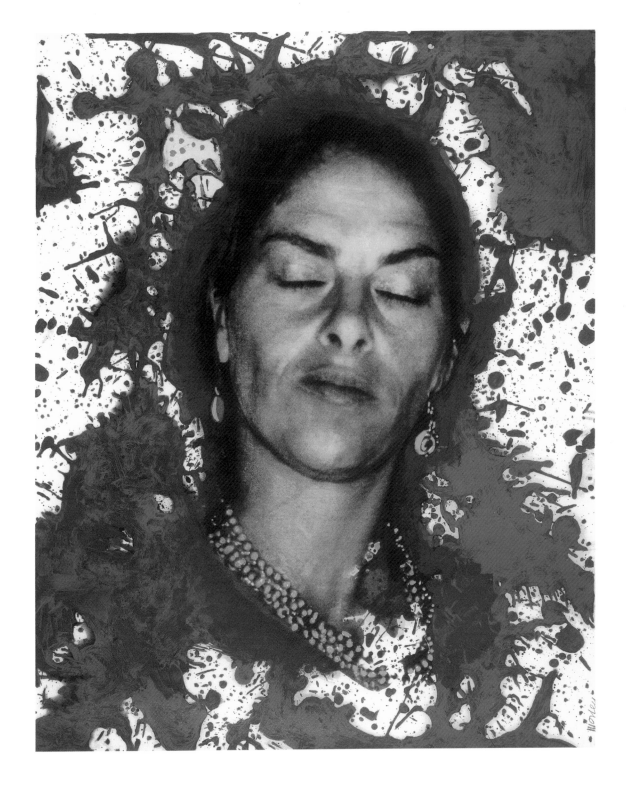

Tracey Emin is alive ... 2003
digital print on canvas, 97.5 x 79 cm    63

# Reportage

**Rue de Rivoli, Paris** late 1950s (detail)
gelatin silver photograph, 22.1 x 22 cm

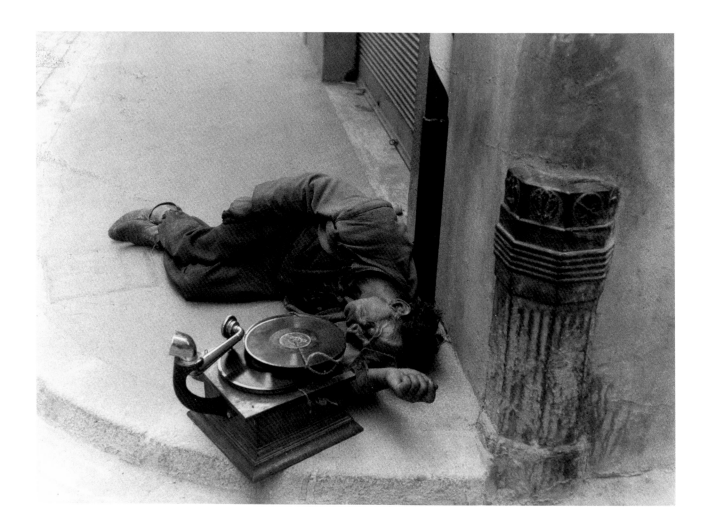

Florence, Italy 1950s
66    gelatin silver photograph, 25.7 x 35.6 cm

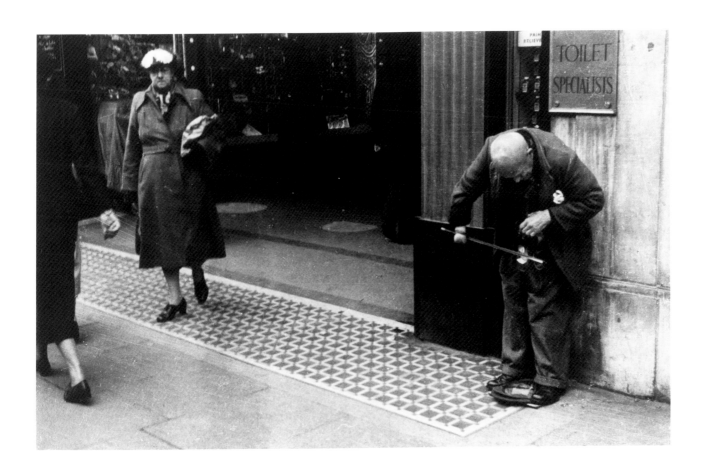

One-handed fiddle player, Regent Street, London late 1950s – early 1960s
gelatin silver photograph, 14.1 x 22.1 cm    67

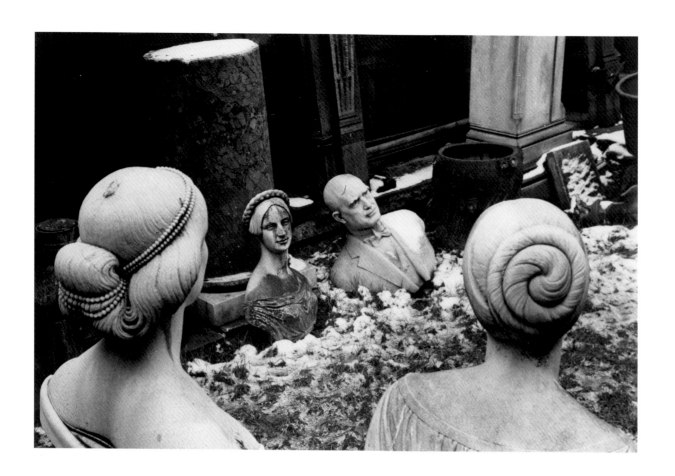

Statue yard, Chiswick, London 1956
gelatin silver photograph, 16.3 x 24.5 cm

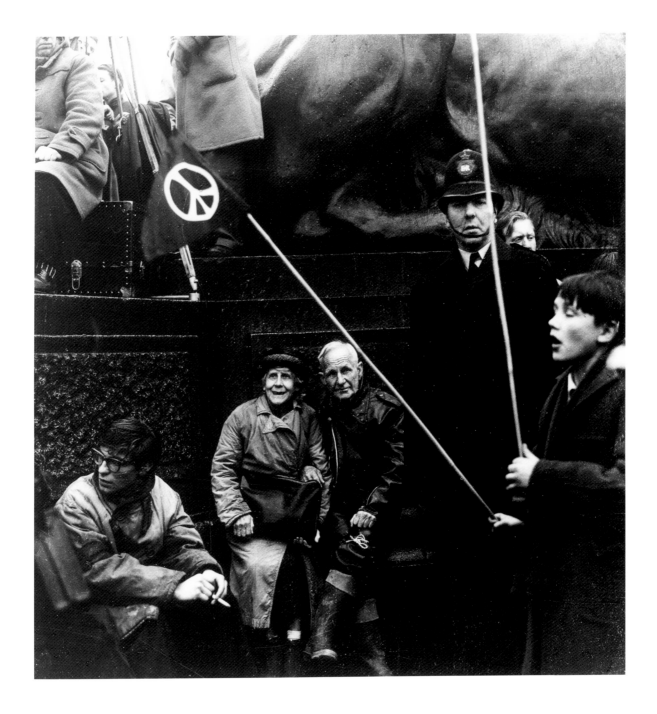

Aldermaston march, Trafalgar Square, London 1958
gelatin silver photograph, 27.9 x 26.3 cm    69

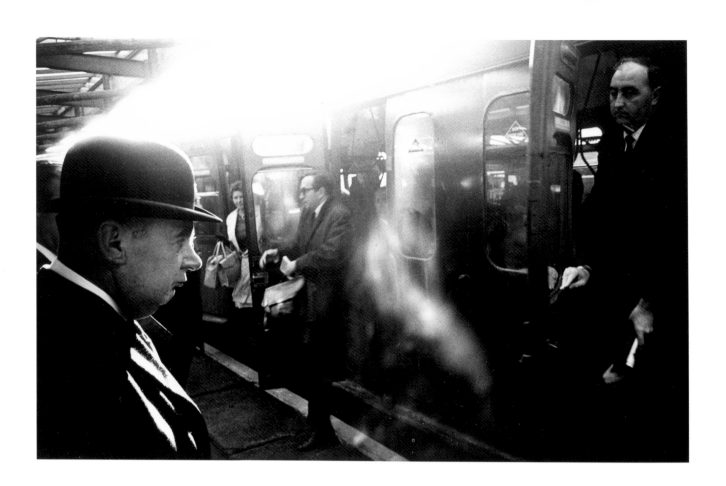

Richmond station, Surrey, England 1959
gelatin silver photograph, 22.8 x 36.2 cm

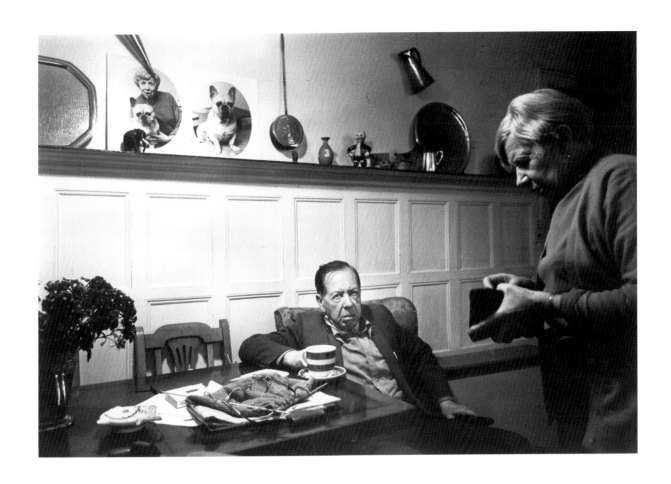

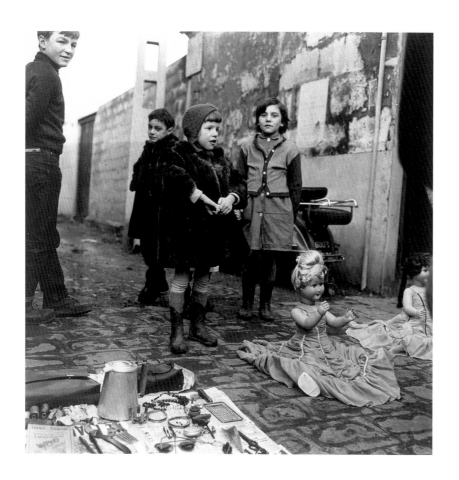

Flea market, Paris 1961
gelatin silver photograph, 18.8 x 18.9 cm

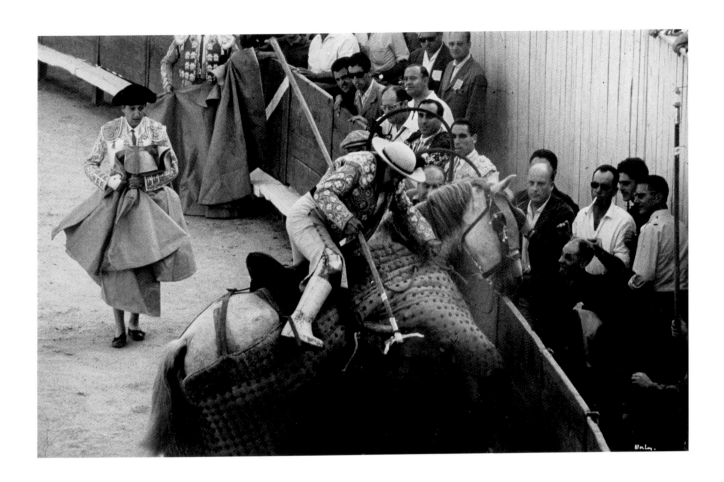

Bullfight, Nîmes, France 1962
gelatin silver photograph, 29.9 x 47.7 cm     73

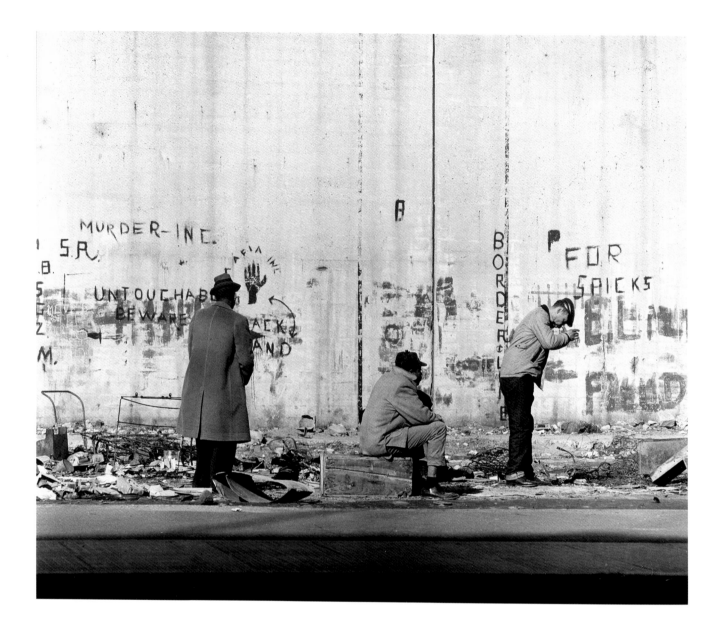

**The Bowery, New York** 1962
74    gelatin silver photograph, 44 x 50.5 cm

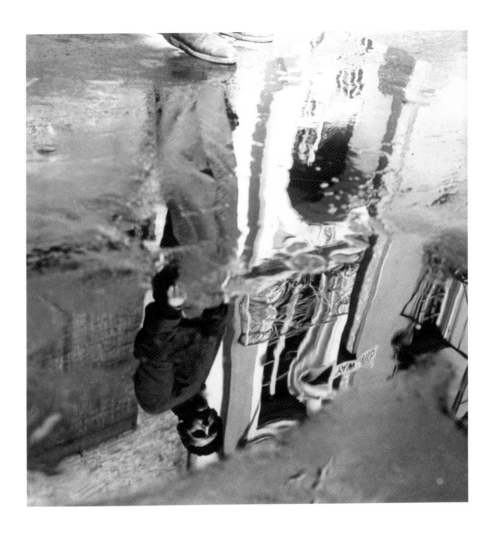

Red Faller, photographer, New York 1962
gelatin silver photograph, 22.3 x 21.7 cm    75

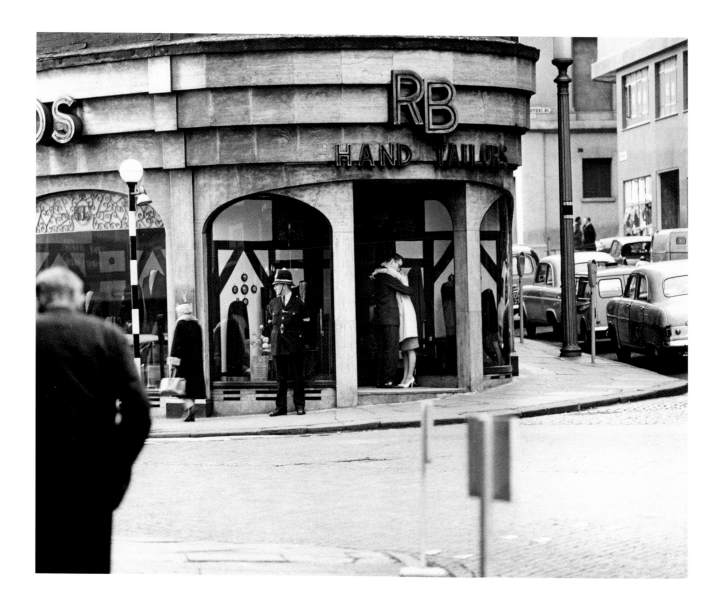

**Birmingham, England** 1963–64
gelatin silver photograph, 40.4 x 50.8 cm

Cosy Café, King's Road, Chelsea, London late 1960s
gelatin silver photograph, 29.9 x 27.6 cm    77

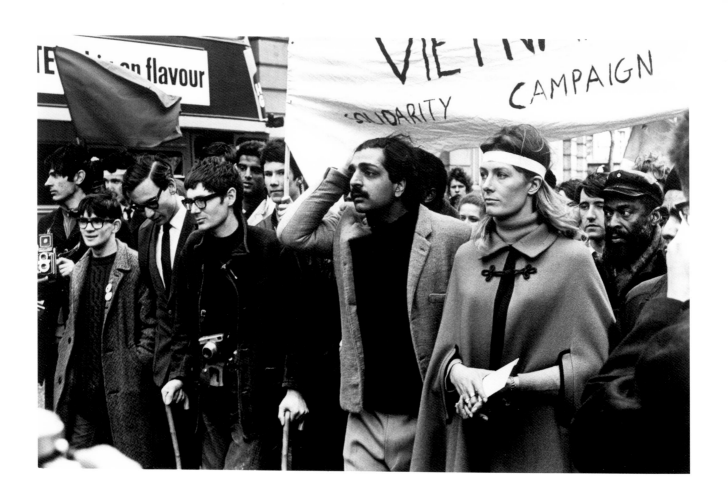

Tariq Ali, Vanessa Redgrave, Noel Tovey and others at the anti-Vietnam war demonstration, London 1968

gelatin silver photograph, 23.2 x 36 cm

Speakers Corner, Hyde Park, London 1960s
gelatin silver photograph, 27.2 x 17.9 cm    79

Nikki South, model, Sydney 1971–72
gelatin silver photograph, 24.6 x 19.6 cm

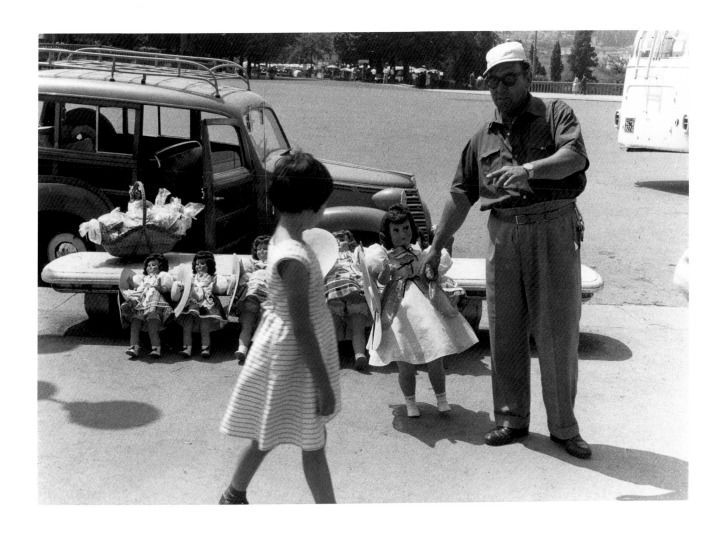

**Berlin** late 1970s
82    gelatin silver photograph, 26.3 x 34.9 cm

Srinagar, India 1977
84    gelatin silver photograph, 23.5 x 35.1 cm

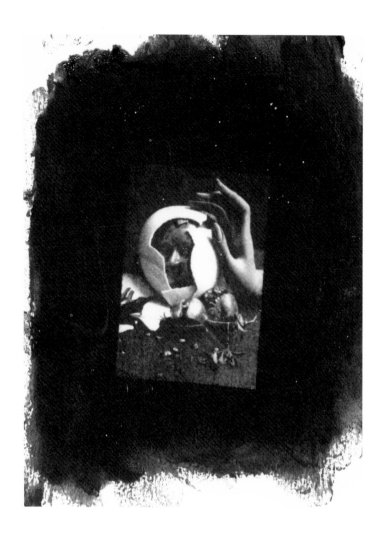

Untitled still life 1981
gelatin silver photograph, 17.7 x 13.3 cm

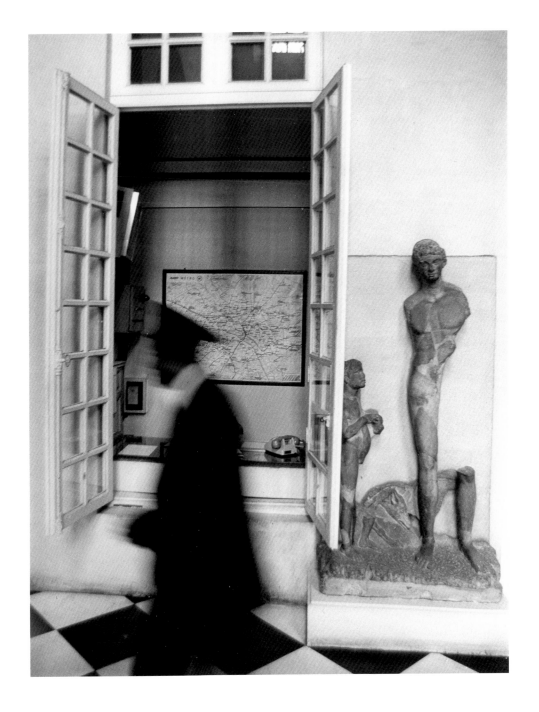

Musée Rodin, Paris 1985
gelatin silver photograph, 30.7 x 23.7 cm    87

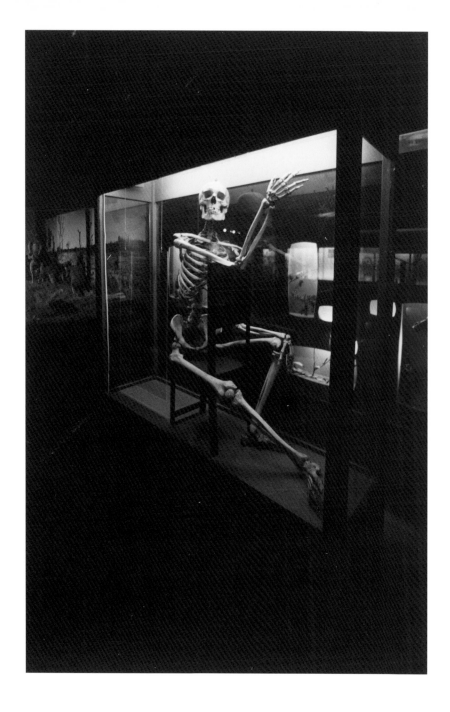

**Skeleton, Hobart Museum, Tasmania** 1990s
gelatin silver photograph, 27.3 x 18 cm

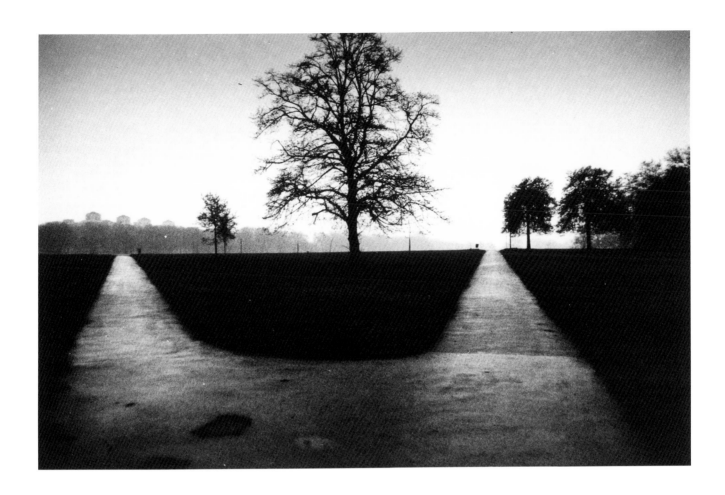

Hampstead Heath, London c1990
gelatin silver photograph, 9.9 x 15.2 cm    89

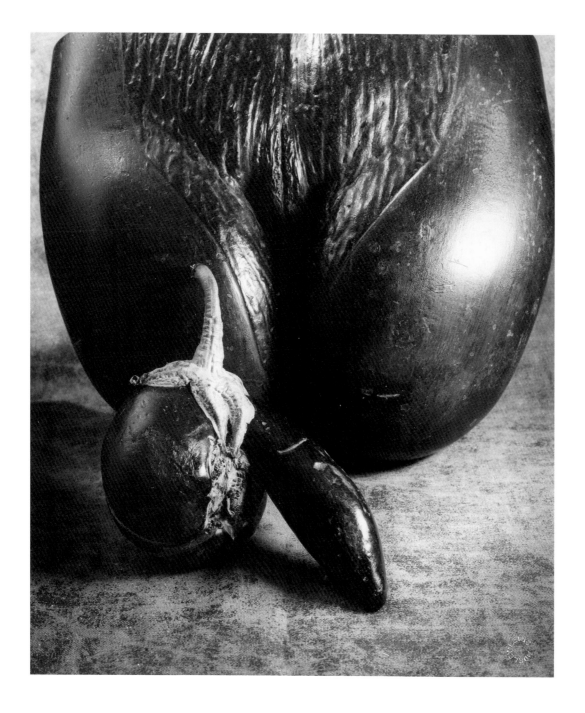

Coco de mer and aubergine 1994
90    gelatin silver photograph, 30.8 x 26 cm

Carousel, Place de la Concord, Paris 2000
gelatin silver photograph, 24.9 x 36.9 cm    91

# Theatre

Nicol Williamson in *The ginger man* by JP Donleavy, Royal Court Theatre, London 1963
gelatin silver photograph, 36.8 x 29.1 cm

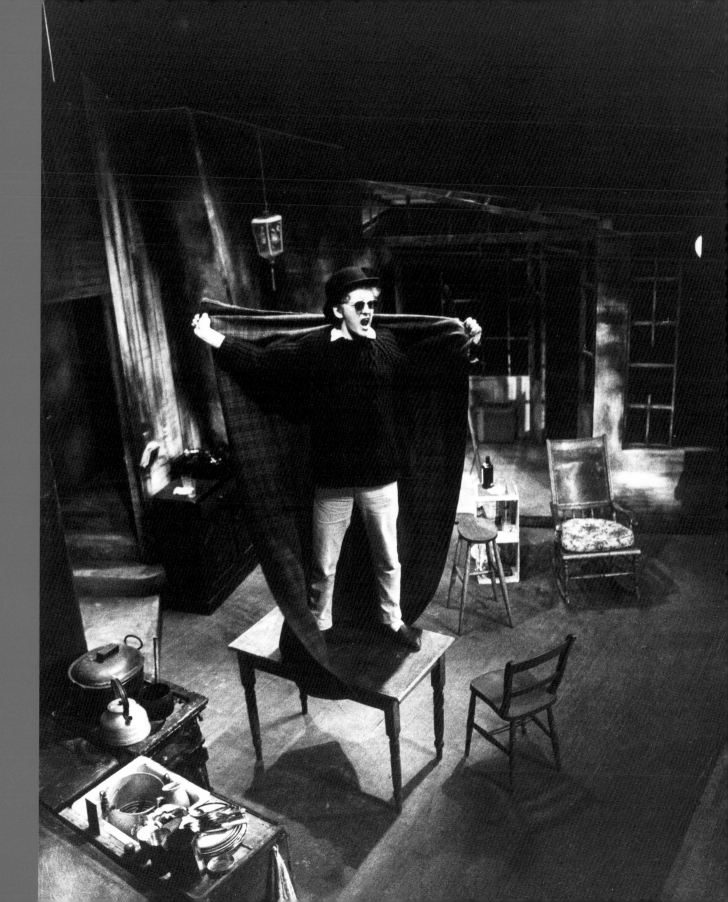

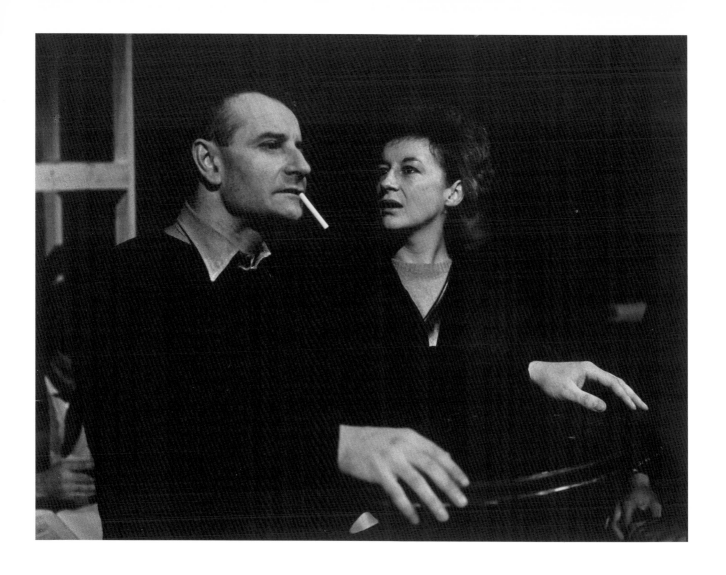

**Zoë Caldwell and Lindsay Anderson, during rehersals for *Trials by Logue*, Royal Court Theatre, London** 1960

gelatin silver photograph, 30.5 x 40.4 cm

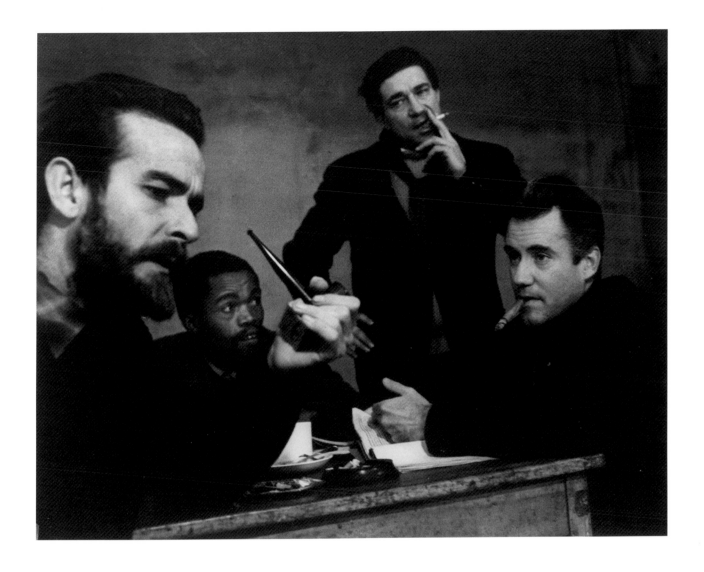

Athol Fugard (author), Zaiks Mokae, John Berry (director) and Ian Bannen in rehearsals for *The blood knot*, New Arts Theatre, London 1963
gelatin silver photograph, 29.2 x 37.4 cm    95

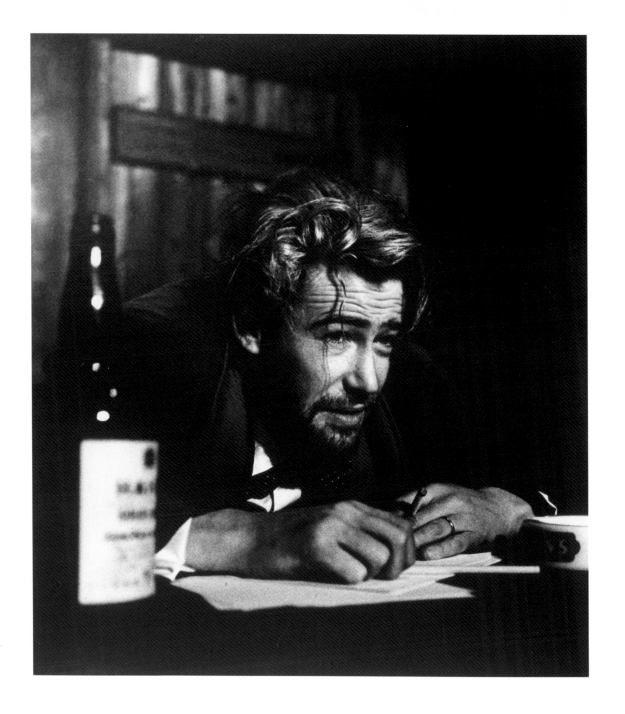

Peter O'Toole in *Baal* by Bertolt Brecht, Phoenix Theatre, London 1963

gelatin silver photograph, 30.2 x 27.4 cm

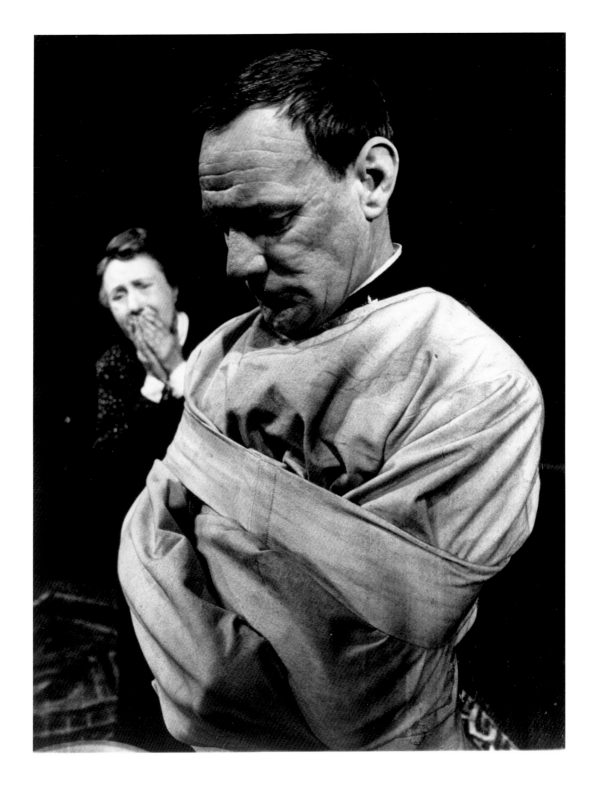

Trevor Howard in *The father* by August Strindberg, Piccadilly Theatre, London 1964
gelatin silver photograph, 39.9 x 30.4 cm     97

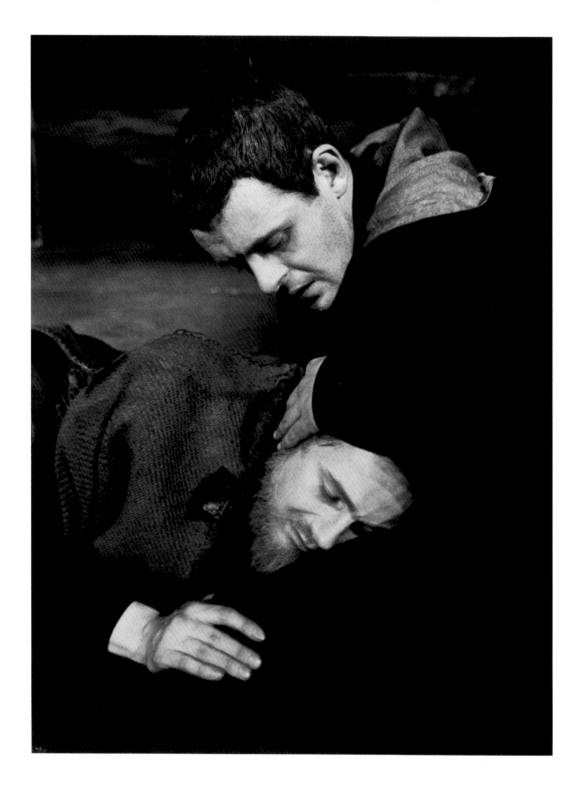

Anthony Hopkins in *Edward II* by Christopher Marlowe, Arts Theatre, London 1964

gelatin silver photograph, 40.4 x 30.4 cm

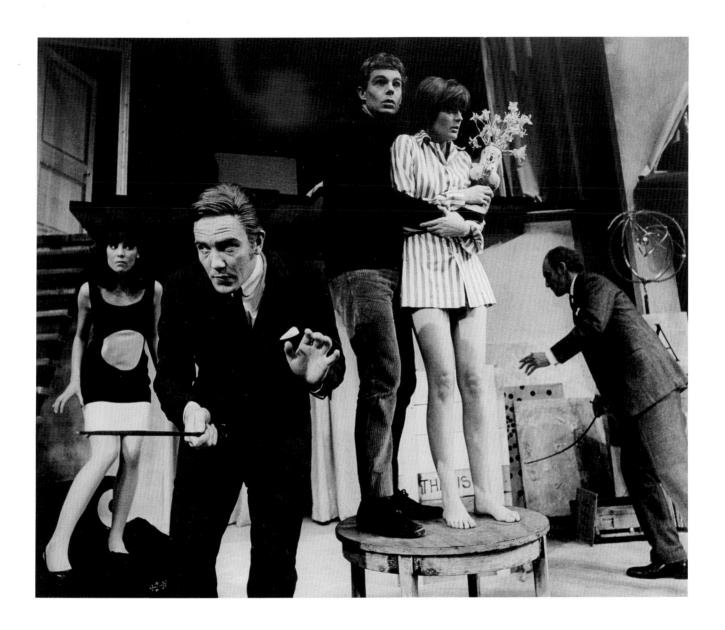

Louise Purnell, Albert Finney, Derek Jacobi, Maggie Smith and Graham Crowden in *Black comedy* by Peter Schaffer, The National Theatre, London 1965
gelatin silver photograph, 24.9 x 29.8 cm     99

# Ephemera

Peter Cook, Dudley Moore, Alan Bennett and Jonathan Miller in *Beyond the fringe*, Fortune Theatre, London 1961 (detail)

100    contact sheet, 20.5 x 25.5 cm

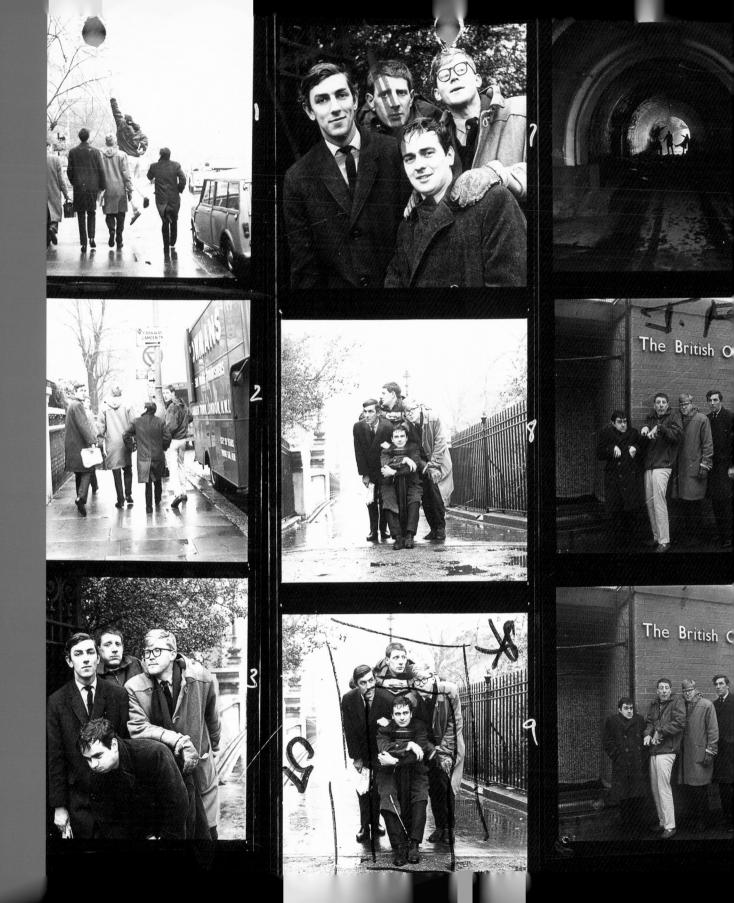

# Portraits

Brian Epstein, entrepreneur,
Liverpool 1963
gelatin silver photograph, 24.8 x 19.9 cm

Brian Epstein, entrepreneur,
Liverpool 1963
contact sheet, 20.5 x 23.5 cm

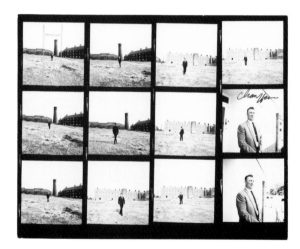

102

Brian Epstein, entrepreneur,
Liverpool 1963
contact sheet, 20.4 x 25.3 cm

At the Cavern nightclub,
Liverpool 1963
gelatin silver photograph, 19.9 x 24.9 cm

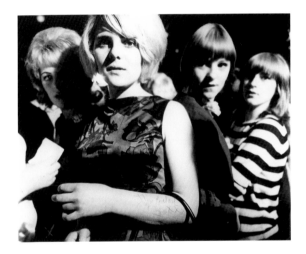

# Theatre

*Sergeant Musgrave's dance*,
Royal Court Theatre, London 1959
program, 18 x 12.5 cm (closed)
Courtesy Royal Court Theatre, London

*Billy Liar*, Cambridge Theatre,
London 1960
photograph by Lewis Morley
tearsheet, 26.5 x 21.5 cm

'The apartheid buster', article
with Athol Fugard (author),
Zaiks Mokae, John Berry (director)
and Ian Bannen in rehearsals for
*The blood knot*, New Arts Theatre,
London 1963
photograph by Lewis Morley
tearsheets, pp 30–31
27.9 x 21.4 cm (each)

*Billy Liar* by Willis Hall and
Keith Waterhouse, Blackie Press,
London 1966
photographs by Lewis Morley
book, pp 46–47, 21 x 13.5 cm (closed)

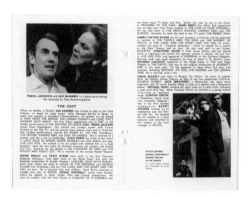

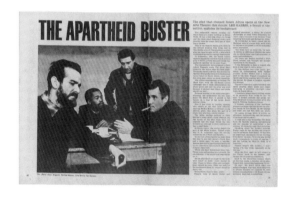

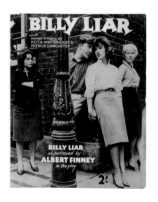

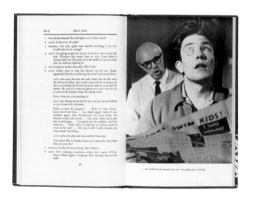

Susan Clark, Charles Gray
and Donald Pleasence in
*Poor Bitos* by Jean Anouilh,
Arts Theatre, London 1964
contact sheet, 20.5 x 25.5 cm

Madge Ryan and Peter Vaughan
in *Entertaining Mr Sloane*
by Joe Orton, Arts Theatre,
London 1964
gelatin silver photograph
19.5 x 24.7 cm

*Entertaining Mr Sloane* by
Joe Orton, Hamish Hamilton,
London 1964
photograph by Lewis Morley
book, cover, 19 x 13 cm
Courtesy Hamish Hamilton, London

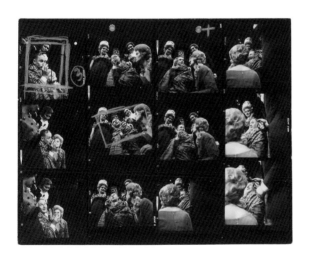

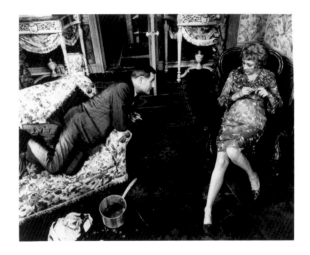

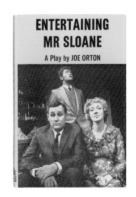

Trevor Howard, Joyce Redman
and Jo Maxwell-Muller in
*The father* by August Strindberg,
Piccadilly Theatre, London 1964
contact sheet, 20.5 x 25.5 cm

Anthony Hopkins in *Edward II*
by Christopher Marlowe,
Arts Theatre, London 1964
contact sheet, 20.5 x 25.5 cm

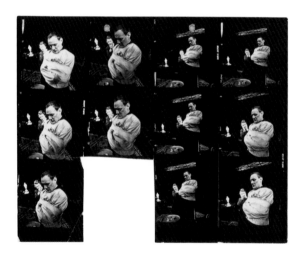

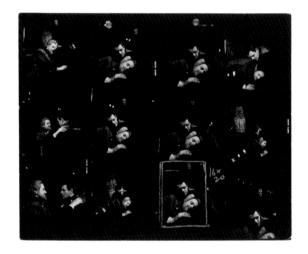

Peter Cook, Dudley Moore,
Alan Bennett and Jonathan Miller
in *Beyond the fringe*, Fortune
Theatre, London 1961
gelatin silver photograph, 20.4 x 25.4 cm

Peter Cook, Dudley Moore,
Alan Bennett and Jonathan Miller
in *Beyond the fringe*,
Fortune Theatre, London 1961
contact sheet, 20.5 x 25.5 cm

*Beyond the fringe*,
Fortune Theatre, London 1961
photograph by Lewis Morley
program, 23.4 x 17.2 cm

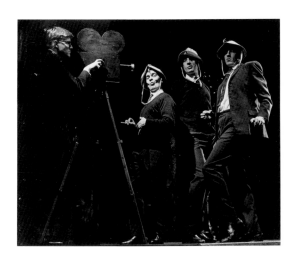

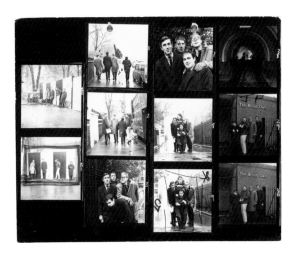

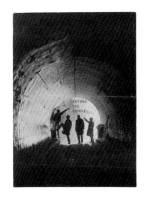

*That was the week that was,*
London 1962–64
contact sheet, 20.5 x 25.5 cm

*That was the week that was,*
WH Allen, London 1963
photographs by Lewis Morley
book, cover and pp 132–33
28.5 x 22 cm (closed)
Courtesy Harper Collins Publishers,
London. *That was the week that was*
is a BBC branded property

Dudley Moore and Peter Cook
mid 1960s
type C photograph, 20.5 x 20.5 cm

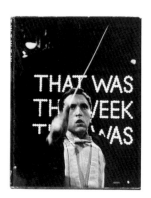

*The Penguin private eye*,
Private Eye/Penguin Books,
London 1965
photograph by Lewis Morley
book, cover, 31.5 x 22.5 cm
Courtesy Penguin Books, UK

*How to play football* by
William Rushton, Margaret
and Jack Hobbs, London 1968
photographs by Lewis Morley
book, pp 46-47, 22 x 14.5 cm (closed)

*Private Eye*, 5 Dec 1969
photograph by Lewis Morley
magazine, cover, 28.5 x 22.5 cm
Courtesy *Private Eye*, London

*Dud and Pete: the Dagenham
dialogues*, Peter Cook and
Dudley Moore, Methuen & Co,
London 1971
photographs by Lewis Morley
book, pp 28–29, 25.5 x 13 cm (closed)
Courtesy Methuen Publishers Ltd, UK

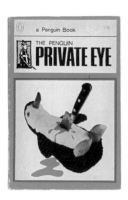

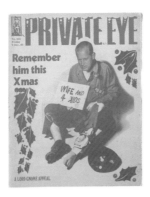

# List of works

Unless otherwise stated, all works are gelatin silver photographs from the collection of Lewis Morley; measurements are given as h x w x d; publication dimensions are closed size.

Drawings from the Stanley internment camp, Hong Kong 1941–45
digital prints, 8 drawings
18.5 x 11.8 cm – 18.3 x 27 cm E001

'Lewis Morley ... painter, photographer', *Photography* magazine Nov 1957
photographs by Lewis Morley
magazine, pp 30–31
25.5 x 20.5 cm E002 [p 9]

*Photography* year book 1960
photographs by Lewis Morley
book, p 46
27.4 x 21.5 cm E003

'Top shots', *Evening Standard* 4 April 1963
newspaper, n/p
41.6 x 32.2 cm E004

'Theatre photography special', *Plays and Players*, July 1963
magazine, n/p
27.5 x 21 cm E014

Lewis Morley, photographer 1964
poster
43 x 31.5 cm E005

'Lewis Morley has departed' 1964
studio address card
17.5 x 45 cm E006

'Made in Italy', *Belle* July/Aug 1976
photograph by Lewis Morley
magazine, pp 76–77
31.9 x 23.1 cm E007

'Gutter gallery', *Pol*, Aug/Sept 1977
photographs by Lewis Morley
magazine, pp 104–105
31.5 x 22.5 cm E015

Assemblage 1980s
mixed media
30.5 x 25.9 x 6.9 cm E011 [p 20]

'A New York state of mind: Lee Radziwill in Southampton' *Belle* July/Aug 1980
photograph by Lewis Morley
magazine, n/p
31.9 x 23.1 cm E009

*My very special cookbook*, Margaret Fulton, Octopus Books, Sydney 1980
photographs by Lewis Morley
book cover
29.4 x 22.3 cm E010

Sea horse 1984
bronze on wood base
11.5 x 23.8 x 5.1 cm object,
4.8 x 9.2 x 6.2 cm base E017

Invitation for *The photographer of the sixties*, National Portrait Gallery, London 1989
card with envelope
15 x 21.1 cm /16.2 x 22.9 cm E016

Prague 1992
words Shura Shihwarg
photograph by Lewis Morley
card
16.6 x 10.2 cm E012

'The man who shot the sixties: the life and pictures of Lewis Morley', *Observer Magazine*, 14 Feb 1993
magazine, cover
34 x 23.5 cm E013

## Fashion

Fashion, Paris 1959–61
28.1 x 27.6 cm F001

Fashion, Paris 1959–61
28.7 x 23.5 cm F002 [p 32]

Sally Greenhill, model, Pont de Grenelle, Paris 1959–61
32.2 x 27.8 cm F003

Maggie Eckhardt, model, London 1960
type C photograph
27.8 x 35.6 cm F004

Tinka Paterson, model, London 1960
22.6 x 21.3 cm F005

Jean Shrimpton and Chris Powell, racecourse fashion for *Go!* 1961
31.4 x 26.8 cm F006 [p 33]

Susannah York, Paris, for *Go!* 1961
33.3 x 29.8 cm F007

London fashion (James Wedge hat) 1962
27.1 x 22.1 cm F008

Anna Lee in front of Eros statue, Piccadilly Circus, London c1963
18.3 x 18.6 cm F009

Bobby Moore, captain of the English soccer team, London, for *She* 1963–64
44 x 30.4 cm F013 [p 34]

Jenny Boyd for *She* 1965
29 x 24 cm
Collection Art Gallery of New South Wales, gift of David Knaus 2005
F010 [p 35]

Twiggy for *London Life* 1965
31.7 x 20.3 cm F011

Mog Smith, fashion designer, London 1965
27.3 x 25.8 cm F012 [p 36]

Marie-Lise Grey, for *She* c1965
36.7 x 26.4 cm F014

Mynah Bird and Pete Smith on Camber Sands, England 1966
37.7 x 28.5 cm F015

Barry Fantoni, Willie Rushton and Diana Clark, spoof fashion for *Private Eye* 1967
32.7 x 30.6 cm F016

Chain-mail fashion for *She* 1969
24 x 30.2 cm F017

Chain-mail fashion for *She* 1969
30.6 x 27.5 cm F018 [p 37]

*Dolly* fashion, Sydney 1974
Cibachrome
30.2 x 24.2 cm F019 [p 31]

### Fashion ephemera

'National Prize', *She* 1960s
photograph by Lewis Morley
tearsheet, p 31
33.5 x 24.2 cm FE001

'Innocents in Paris', Susannah York for *Go!*, June 1961
magazine, pp 26–27
31.6 x 23.8 cm FE002

'The case of the sinful brunette', *Daily Mirror*, London, 15 Aug 1963
photographs by Lewis Morley
newspaper, p 11
36.5 x 43.5 cm FE003

Claire Bloom wearing
Mary Quant for *She* 1963
photograph by Lewis Morley
tearsheet, p 46
33 x 24 cm FE004

'What people are wearing',
*London Life*, 8–12 Jan 1965
Susannah York and Twiggy
photographs by Lewis Morley
tearsheet, p 23
31.5 x 23.9 cm FE005 [p 13]

'Masters of men', *Harpers
Bazaar*, Jan/Feb 1969
photographs by Lewis Morley
magazine, pp 76-77
32 x 24 cm FE006

Chain-mail fashion 1969
contact sheet
25.7 x 30.9 cm FE007

# Portraits

Hussein Sheriff, painter,
London 1958
25.2 x 32.6 cm P001 [p 40]

Self-portrait in a mirror
with Pat, Paris 1959
27.8 x 26.2 cm P002 [p 1]

Cecil Beaton, Royal Hospital
Chelsea, London 1959/60
41.5 x 30.3 cm P003

Salvador Dalí, London 1960
50.5 x 40.5 cm P004 [p 41]

Geoffrey Fisher, archbishop
of Canterbury, London 1960
39.4 x 29.1 cm P005

Charlotte Rampling, London
early 1960s
27.9 x 36.8 cm P006 [p 42]

Lord mayor's banquet, London
mid 1960s
gelatin silver photograph, solarised
40.5 x 50.3 cm P007

Kenneth Horne, art critic/comedian,
for *She*, London mid 1960s
39.8 x 29.4 cm P008 [p 48]

Nancy Spain at the Albert
Memorial, London, annotating
Voltaire's notebook mid 1960s
24.9 x 20.8 cm P009

Alan Bennett, Peter Cook,
Jonathan Miller and Dudley Moore
for *Beyond the fringe* publicity,
London 1961
29.1 x 35.6 cm P010 [p 47, pp 122–23]

Somerset Maugham, San Tropez,
France 1961
36.7 x 27.9 cm P011 [p 43]

Arthur Koestler, writer, political
activist and social philosopher,
Montpelier Square, London 1961
30.2 x 40.4 cm P012

François Truffaut, London 1961
12.3 x 17.6 cm P013 [p 44]

Mrs Jonathan Miller, Brighton,
England 1961
29.5 x 34 cm P014

Paul Hamlyn, publisher,
London c1961
26.2 x 36.1 cm P015

Terence Greer, playwright,
outside Gare St Lazare, Paris 1962
13.9 x 19.3 cm P016 [p 45]

Roddy Maude Roxby, actor,
Soho Square, London 1962
38.8 x 29 cm P017 [p 46]

Is this Alfred Eisenstadt?
At John Glenn's Parade,
Wall Street, New York 1962
12.1 x 17.8 cm P018

Christine Keeler, London 1963
gelatin silver photograph, aniline dye
43.5 x 22.3 cm
Collection Art Gallery of New South
Wales, purchased 2004 P019 [p 6]

Barry Humphries, London 1963
34.6 x 29.2 cm P020

Victor Spinetti, War Memorial,
Hyde Park, London, publicity shot
for *Oh! what a lovely war* 1963
40.6 x 50.6 cm P021 [p 50]

Christine Keeler, London 1963
33.1 x 25.7 cm P022 [p 49]

Dudley Moore as the Fairy Queen,
Frith Street, London, for *Private
Eye* 1963–64
24.9 x 19.2 cm P023 [p 39]

Franco Zeffirelli, National Theatre,
London 1964
20.9 x 15.8 cm P024

Pauline Boty, artist, London c1964
Cibachrome
30.5 x 25.5 cm P025 [p 51]

Joe Orton, playwright, London 1965
35 x 28.8 cm
Collection Art Gallery of New South
Wales, gift of David Knaus 2005 P026
[p 53]

Donovan, musician, London 1965
17.9 x 17.5 cm P027

Judi Dench, actor, London 1965
31 x 30.2 cm P028

Joe Orton, playwright,
London 1965
16.7 x 16.9 cm P029

Joe Orton, playwright,
London 1965
12.5 x 12.9 cm P030

André Previn, conductor/composer,
Grosvenor Hotel, London c1965
20.1 x 25.1 cm P031 [p 52]

Jeff Beck, musician, London 1967
30 x 41.4 cm P032

Jude Kuring, artist, Sydney
early 1970s
35.1 x 24.1 cm P033 [p 56]

Sculptress with macramé
body suit, Sydney early 1970s
21.7 x 29.1 cm P034

Pat, Germany late 1970s
18.3 x 13.6 cm P035 [p 54]

Ben Eriksson and Rodney
Weidland, photographers,
Sydney 1972
37.1 x 30.3 cm P036

Swedish ambassador and
his wife, Sydney 1972
26.8 x 22.1 cm P037

Sherbet, Sydney 1972
19.2 x 24.7 cm P038

John Firth-Smith, artist,
Sydney 1974
18.4 x 18.9 cm P039

John Kaldor, Sydney 1975
36.6 x 22.6 P040

Helen Glad, Norman Lindsay's
granddaughter, Sydney 1975
Cibachrome
41 x 51 cm P041 [p 55]

Self-portrait, Sri Lanka 1977
30.9 x 23.1 cm P042 [p 28]

Self-portrait, Sydney c1978
16.9 x 24.3 cm P043

Christo wrapped 1980
gelatin silver photograph, paper,
string, perspex box
73 x 93 x 9.5 cm (overall)
Museum of Contemporary Art, Sydney,
gift of the artist 1982 P057 [p 59]

Self-portrait with enamel bacon
and eggs, Sydney c1980
30.2 x 23.6 cm P044 [p 58]

Hunter S Thompson, writer,
Sydney early 1980s
17 x 24.5 cm P045

Pat and self-portrait reflection,
Sydney mid 1980s
23.7 x 16.1 cm P046 [p 57]

Lloyd Rees, Sydney 1984–88
29.7 x 40 cm P047

Pat at the Musée Rodin,
Paris 1985
18.6 x 12.2 cm P048

Kerry Crowley, gallerist,
'Another time, another place,
another chair', Sydney 1988
29.9 x 40.3 cm P051 [p 60]

Wednesday Kennedy, actor,
Sydney 1990
28.1 x 21.2 cm P049 [p 61]

Sarah Lucas, artist,
Berlin late 1990s
30.6 x 19 cm P050 [p 62]

Barry Humphries on his
60th birthday, Sydney 1994
25.8 x 18.7 cm P052 [p 24]

Margaret Olley, Sydney c1998
24.3 x 36.8 cm P053

Beth Orton, musician,
Diss station, Norfolk,
England c2000
28.4 x 36.4 cm P054

Fritz Gruber and his wife,
collector, Cologne early 2000s
23.9 x 17.2 cm P055

Tracey Emin is alive ... 2003
digital print on canvas
97.5 x 79 cm P056 [p 63]

## Portrait ephemera

Kenneth Jupp, playwright, for
Tatler & Bystander, 26 Nov 1958
tearsheet, p 511
31.6 x 23.6 cm PE001

Christine Keeler 1963
contact sheets
20.7 x 29.1 cm PE003, PE004 [p 10], PE005

'Christine Keeler's secret
screen test', Modern Screen,
Nov 1963
magazine, n/p
27.5 x 21.5 cm PE006

Brian Epstein, entrepreneur,
Liverpool 1963
24.5 x 19.7 cm PE002

Brian Epstein, entrepreneur,
Liverpool 1963
24.8 x 19.9 cm PE007 [p 102]

Brian Epstein, entrepreneur,
Liverpool 1963
contact sheets
20.5 x 23.5 cm PE008 [p 102], PE010,
PE011, PE012
20.4 x 25.3 cm PE009 [p 103]

Brian Epstein with his parents,
Liverpool 1963
19.7 x 24.8 cm PE013

At the Cavern nightclub,
Liverpool 1963
19.9 x 24.9 cm PE014 [cover, p 103]

The Kremlin letter by Noel Behn,
W H Allen, London 1966
cover design by Lewis Morley
dust jacket
20.5 x 30.5 cm (open) PE015

Sherbet, Sydney 1972
type C photograph
24.2 x 29.7 cm PE016

Brett Whiteley, artist, Sydney 1974
photograph by Lewis Morley
tearsheet
27.3 x 41.8 cm PE017

'Self-portrait' for Pol, autumn 1975
photograph by Lewis Morley
magazine
31.5 x 23 cm PE018 [p 11]

Helen Glad, Pol, summer 1975/76
photograph by Lewis Morley
magazine, pp 62–63
31.9 x 23 cm PE019

'Facing up', Sun Herald,
15 Sept 1991
newspaper, p 127
42.2 x 29.6 cm PE020

The naked spy by Captain Yevgeny
Ivanov with Gennady Sokolov,
Blake Publishing 1994
photographs by Lewis Morley
book cover
18 x 11.2 cm PE021

'That's education',
Amateur Photographer,
25 Oct 1997
magazine, pp 14–15
29.6 x 21.1 cm PE022

'Dame Edna Everage',
Times Literary Supplement,
15 May 1998
photograph by Lewis Morley
magazine cover
37.5 x 29 cm PE023

'Freeze frame: the story behind
that image', Sunday Magazine:
Herald Sun, 26 May 2002
magazine cover
31.4 x 25.5 cm PE024

'The naked truth',
Sun Herald TV Magazine,
16–22 March 2003
magazine cover
27.6 x 20 cm PE025

## Reportage

Florence, Italy 1950s
25.7 x 35.6 cm R001 [p 66]

Corner, no 84 Charing Cross Rd,
London late 1950s
24.5 x 30.1 cm R002

Rue de Rivoli, Paris late 1950s
22.1 x 22 cm R003 [detail p 65]

Christmas, Regent Street,
London late 1950s
15.2 x 20.7 cm R004

One-handed fiddle player,
Regent Street, London
late 1950s – early 1960s
14.1 x 22.1 cm R005 [p 67]

Statue yard, Chiswick, London 1956
16.3 x 24.5 cm R006 [p 68]

Regent's Park zoo, London 1957
20.7 x 14 cm R007

Bride in the rain, Hammersmith,
London 1957
23.6 x 34.9 cm R008

Regent's Park zoo, London 1957
16 x 18.5 R009

Watching the trooping of the
colour, London 1957
25.8 x 38.2 cm R010

Train spotter, Richmond line,
Surrey, England 1957
26.3 x 38.7 cm R011

Aldermaston march,
Trafalgar Square, London 1958
27.9 x 26.3 cm R012 [p 69]

Luxembourg Gardens,
Paris 1958
23.5 x 36.2 R013

Fairground faces, Cavesham,
England 1959
23.5 x 36.2 cm R014

Richmond station, Surrey,
England 1959
22.8 x 36.2 cm R015 [p 70]

Speakers Corner, Hyde Park,
London 1960s
27.2 x 17.9 cm R016 [p 79]

Margarine advertisement,
London 1960s
20.4 x 31.9 cm R017

Queenie and her husband,
London 1960s
14 x 20.5 cm R018 [p 71]

Cosy Café, King's Road,
Chelsea, London late 1960s
29.9 x 27.6 cm R019 [p 77]

Flea market, Paris 1961
18.8 x 18.9 cm R020 [p 72]

Bullfight, Nîmes, France 1962
29.9 x 47.7 cm R021 [p 73]

The Bowery, New York 1962
44 x 50.5 cm R022 [p 74]

American sailors, Puerto Rico 1962
27.6 x 25.5 cm R023 [back cover]

Red Faller, photographer,
New York 1962
22.3 x 21.7 cm R024 [p 75]

The Bowery, New York 1962
18.3 x 18.3 cm R025

Nuns, Paris 1963
23 x 35.1 cm R026

Children, Sierra Leone 1963
27.7 x 28.2 cm R027

Birmingham, England 1963–64
40.4 x 50.8 cm R028 [p 76]

Gorbals, Glasgow 1964
35.9 x 24.7 cm R029

Anti-Vietnam war demonstration,
Trafalgar Square, London 1968
24.1 x 36.8 cm R030

Anti-Vietnam war demonstration,
London 1968
23.7 x 36.2 cm R031

Tariq Ali, Vanessa Redgrave,
Noel Tovey and others at the
anti-Vietnam war demonstration,
London 1968
23.2 x 36 cm R032 [p 78]

Fraser Nash car rally,
Stelvio Pass, Italy 1969
20.5 x 31.3 cm R033

Dolls, Italy 1970s
24.2 x 34.5 cm R034 [p 81]

Berlin late 1970s
26.3 x 34.9 cm R035 [p 82]

Paris late 1970s
21 x 31.2 cm R036

Paris late 1970s
22.6 x 34.1 cm R037 [p 83]

John Olsen's dog in front of
Nolan's Ned Kelly, Sydney
mid – late 1970s
9.1 x 9.1 cm R038

Nikki South, model, Sydney
1971–72
24.6 x 19.6 cm R039 [p 80]

Kashmir, India 1977
23.9 x 35.1 cm R040 [p 85]

Observatory area, Centre
Pompidou, Paris 1977
23.1 x 34.5 cm R041

Srinagar, India 1977
23.5 x 35.1 cm R042 [p 84]

Srinagar, India 1977
34.9 x 23.9 cm R043

Paris c1980
24.5 x 25 cm R044

Fossilised flower 1980s
23.9 x 19 cm R045

Street sign, Europe 1980s
28.8 x 23.5 cm R046

Untitled still life 1981
17.7 x 13.3 cm R047 [p 86]

Street crossing, Tokyo,
Japan 1982
32.7 x 20.9 cm R048

Garden at the Musée Rodin,
Paris 1985
30.1 x 25.3 cm R049 [p 124]

Musée Rodin, Paris 1985
30.7 x 23.7 cm R050 [p 87]

Hampstead Heath, London c1990
9.9 x 15.2 cm R051 [p 89]

Skeleton, Hobart Museum,
Tasmania 1990s
27.3 x 18 cm R052 [p 88]

Prague 1992
31.6 x 21.4 cm
Collection Art Gallery of New South
Wales, gift of David Knaus 2005
R053 [p 15]

Charles bridge, Prague 1992
12.1 x 17.5 cm R054

Tombstone, Japan 1993
12.3 x 7 cm R055

Coco de mer and aubergine 1994
30.8 x 26 cm R056 [p 90]

Carousel, Place de la Concord,
Paris 2000
24.9 x 36.9 cm R057 [p 91]

## Reportage ephemera

'Fire hits Chelsea',
Photography Magazine, Aug 1959
photographs by Lewis Morley
magazine, pp 44-45
25 x 20 cm RE002

'Fire hits Chelsea' 1959
contact sheet
16.4 x 22.5 cm RE009

'Fairground faces', *Tatler* & *Bystander*, 19 Aug 1959
photographs by Lewis Morley
magazine tearsheet, pp 24–25
47.6 x 31.7 cm RE003

'I talk to him all the time ...' 1960s
photograph by Lewis Morley
newspaper tearsheets, n/p
32.8 x 25.1 cm (each) RE001

'The children in our care' 1960s
photograph by Lewis Morley
newspaper tearsheet, pp 10–11
32.8 x 50.4 cm RE004

Sierra Leone television,
its purpose and pattern 1963
photographs by Lewis Morley
book
21 x 34.5 cm RE005

'The Mersey girls',
*Woman's Mirror*, 21 March 1964
photographs by Lewis Morley
magazine, pp 4–5
33 x 25.5 cm RE006 [p 17]

'Here's to the lassies!',
*Woman's Mirror*, 29 Feb 1964
photographs by Lewis Morley
magazine, pp 4–5
33 x 25.5 cm RE007

'The friendship industry',
*London Life*, 12 Feb 1966
photograph by Lewis Morley
magazine, n/p
28.1 x 21.7 cm RE008 [p 13]

# Theatre

Albert Finney in *Billy Liar* by
Keith Waterhouse and Willis Hall,
Cambridge Theatre, London 1960
24.6 x 19.9 cm T001

Zoë Caldwell and Lindsay
Anderson, during rehersals for
*Trials by Logue*, Royal Court
Theatre, London 1960
30.5 x 40.4 cm T002 [p 94]

Peter Cook, Dudley Moore,
Alan Bennett and Jonathan Miller
in *Beyond the fringe*,
Fortune Theatre, London 1961
29 x 28.6 cm T003

Peter O'Toole in *Baal* by
Bertolt Brecht, Phoenix Theatre,
London 1963
30.2 x 27.4 cm T004 [p 96]

Athol Fugard (author), Zaiks
Mokae, John Berry (director)
and Ian Bannen in rehearsals for
*The blood knot*, New Arts Theatre,
London 1963
29.2 x 37.4 cm T005 [p 95]

Michael Caine and Barry Foster
in *Next time I'll sing to you* by
James Saunders, New Arts
Theatre, London 1963
31.2 x 25.9 cm T006

Nicol Williamson in
*The ginger man* by J P Donleavy,
Royal Court Theatre, London 1963
36.8 x 29.1 cm T007 [p 93]

Trevor Howard in *The father*
by August Strindberg,
Piccadilly Theatre, London 1964
39.9 x 30.4 cm T008 [p 97]

Anthony Hopkins in *Edward II*
by Christopher Marlowe,
Arts Theatre, London 1964
40.4 x 30.4 cm T009 [p 98]

Michael Crawford, Hazel
Corpen and Henry H Corbett
in *Travelling light* by Leonard
Kingston, Prince of Wales Theatre,
London 1965
50.5 x 40.7 cm T010

Louise Purnell, Albert Finney,
Derek Jacobi, Maggie Smith
and Graham Crowden in
*Black comedy* by Peter Schaffer,
The National Theatre, London 1965
24.9 x 29.8 cm T011 [p 99]

Rodney Bewes, Tim Preece,
John Hurt and Kenneth Colley
in *Little Malcolm and his
struggle against the eunuchs*,
Garrick Theatre, London 1966
16.7 x 20.6 cm T012

John Hurt in *Little Malcolm and
his struggle against the eunuchs*,
Garrick Theatre, London 1966
30.7 x 30.2 cm T013

Tim Preece, Kenneth Farrington
and June Liversidge in *KD Dufford
hears KD  Dufford ask KD Dufford
how KD Dufford'll make KD Dufford*
by David Halliwell, LAMDA Theatre,
London 1969
37.9 x 38.2 cm T014

Warren Mitchell and cast in
*The council of love* by Oscar
Panizza, Criterion Theatre,
London 1970
26.2 x 25.5 cm T015

## Theatre ephemera

*Sergeant Musgrave's dance*,
Royal Court Theatre, London 1959
program
18 x 12.5 cm TE002 [p 104]

*Trials by Logue*,
Royal Court Theatre, London 1960
photograph by Lewis Morley
program
18.5 x 12.5 cm TE003

*Billy Liar*, Cambridge Theatre,
London 1960
photograph by Lewis Morley
tearsheet
26.5 x 21.5 cm TE004 [p 104]

*Billy Liar*, Cambridge Theatre,
London 1960
photographs by Lewis Morley
program
24 x 17 cm TE005

*Dudley Moore and Peter Cook*
mid 1960s
type C photograph
20.5 x 20.5 cm TE006 [p 108]

*Fairy tales of New York*,
Comedy Theatre, London 1961
photograph by Lewis Morley
program
21.5 x 14 cm TE007

*Beyond the fringe*,
Fortune Theatre, London 1961
photograph by Lewis Morley
program
23.4 x 17.2 cm TE008 [p 107]

*Beyond the fringe*,
Theatre Royal, Brighton 1961
flyer
18.8 x 12.4 cm TE009

'Fairy tales of New York', *Plays and Players*, March 1961
photograph by Lewis Morley
magazine, pp 12–13
27.7 x 21.4 cm TE010

Peter Cook, Dudley Moore, Alan Bennett and Jonathan Miller in *Beyond the fringe*, Fortune Theatre, London 1961
contact sheets
20.5 x 25.5 cm
TE011 [detail p 101, p 107], TE012, TE013, TE014

Jonathan Miller in *Beyond the fringe*, Fortune Theatre, London 1961
contact sheet
20.5 x 25.5 cm TE015

Peter Cook, Dudley Moore, Alan Bennett and Jonathan Miller in *Beyond the fringe*, Fortune Theatre, London 1961
20.4 x 25.4 cm TE016 [p 107]

Theatre/dining room at The Establishment, London 1962
20.2 x 23.5 cm TE017

*That was the week that was*, London 1962–64
contact sheets
20.2 x 25.5 cm TE018, TE019 [p 108]

*That was the week that was*, London 1963
photograph by Lewis Morley
record cover
31 x 31 cm TE021

*That was the week that was*, WH Allen, London 1963
photographs by Lewis Morley
book, cover and pp 132–33
28.5 x 22 cm TE022 [p 108]

*The Spread of the Eagle: three Roman plays by William Shakespeare*, BBC TV 1963
photograph by Lewis Morley
program
24.5 x 17.5 cm TE023

William Squire and cast in *Cider with Rosie* by Laurie Lee, Hampstead Theatre Club, London 1963
contact sheet
20.5 x 25.5 cm TE025

Marie Kean, Susannah York and Ray McAnally in *Cheap bunch of nice flowers* by Edna O'Brien, Arts Theatre, London 1963
contact sheets
20.5 x 25.5 cm TE024, TE026

'The apartheid buster', article with Athol Fugard (author), Zaiks Mokae, John Berry (director) and Ian Bannen in rehearsals for *The blood knot*, New Arts Theatre, London 1963
photograph by Lewis Morley
tearsheets, pp 30–31
27.9 x 21.4 cm (each) TE027 [p 104]

*Baal*, Phoenix Theatre, London c1963
photograph by Lewis Morley
program
23.7 x 17.5 cm TE028

*Entertaining Mr Sloane* by Joe Orton, Hamish Hamilton, London 1964
photograph by Lewis Morley
book, cover
19 x 13 cm TE029 [p 105]

Madge Ryan and Peter Vaughan in *Entertaining Mr Sloane* by Joe Orton, Arts Theatre, London 1964
19.5 x 24.7 cm TE030 [p 105]

*Private Eye*, 2 Oct 1964
photograph by Lewis Morley
magazine, cover
28.5 x 22.5 cm TE031

Maggie Smith, Robert Stephens, Laurence Olivier, Colin Blakely and Lynn Redgrave in *The recruiting officer* by George Farquhar, The National Theatre, London 1964
postcards (3)
8.9 x 14 cm (each) TE032

'The father', *Drama Quarterly Theatre Review*, spring 1964
photograph by Lewis Morley
magazine, pp 20–21
22.3 x 15.7 cm TE033

Maggie Smith and Lynn Redgrave in *The recruiting officer* by George Farquhar, The National Theatre, London 1964
16.5 X 15.7 cm TE034

Susan Clark, Charles Gray and Donald Pleasence in *Poor Bitos* by Jean Anouilh, Arts Theatre, London 1964
contact sheets
20.5 x 25.5 cm TE035, TE036 [p 105]

Trevor Howard, Joyce Redman and Jo Maxwell-Muller in *The father* by August Strindberg, Piccadilly Theatre, London 1964
contact sheets
20.5 x 25.5 cm TE037 [p 106], TE038

Anthony Hopkins in *Edward II* by Christopher Marlowe, Arts Theatre, London 1964
contact sheet
20.5 x 25.5 cm TE039 [p 106]

Maggie Smith, Robert Stephens, Laurence Olivier, Colin Blakely and Lynn Redgrave in *The recruiting officer* by George Farquhar, The National Theatre, London 1964
contact sheet
20.5 x 25.5 cm TE040

Susan Clark, Charles Gray and Donald Pleasence in *Poor Bitos* by Jean Anouilh, Arts Theatre, London 1964
program
21.7 x 13.9 cm TE041

*The Penguin private eye*, Private Eye/Penguin Books, London 1965
photograph by Lewis Morley
book, cover
31.5 x 22.5 cm TE043 [p 109]

*The recruiting officer*, Kenneth Tynan (ed), Rupert Hart Davis, London 1965
photographs by Lewis Morley
book, pp 82–83
25 x 19 cm TE044

*Billy Liar* by Willis Hall and Keith Waterhouse, Blackie Press, London 1966
photographs by Lewis Morley
book, pp 46–47
21 x 13.5 cm TE045 [p 104]

*Little Malcolm and his struggle against the eunuchs*, Garrick Theatre, London 1966
photographs by Lewis Morley
program
21.5 x 14 cm TE046

*Little Malcolm and his struggle against the eunuchs* 1966
contact sheet
20.5 x 25.5 cm TE047

Alec Guinness in *Wise child,
Plays and Players*, Dec 1967
photograph by Lewis Morley
magazine, cover
27.7 x 21.4 cm TE048

*The anniversary* by William
MacIlwraith, Evans Plays,
London 1967
photograph by Lewis Morley
book, pp 16–17
21 x 14.2 cm TE049

Alec Guinness, Simon Ward,
Gordon Jackson and Cleo
Sylvestre in *Wise child* by
Simon Ward, Wyndhams Theatre,
London 1967
gelatin silver photograph
20.4 x 25.9 cm TE050

*How to play football* by
William Rushton, Margaret
and Jack Hobbs, London 1968
photographs by Lewis Morley
book, pp 46-47
22 x 14.5 cm TE051 [p 109]

*Private Eye*, 5 Dec 1969
photograph by Lewis Morley
magazine, cover
28.5 x 22.5 cm TE052 [p 109]

*Parafinalia* by Ken Campbell,
*The prince, the wolf and the
firebird* by Jackson Lacey,
Unicorn Theatre, London 1969
photographs by Lewis Morley
program TE001

*Dud and Pete: the Dagenham
dialogues*, Peter Cook and
Dudley Moore, Methuen & Co,
London 1971
photographs by Lewis Morley
book, pp 28–29
25.5 x 13 cm TE053 [p 109]

*The plays of JP Donleavy*,
Delacorte Press, New York 1972
photographs by Lewis Morley
book, p 55
23.5 x 16 cm TE054

*Funeral games* by Joe Orton,
Drill Hall Theatre, London 1996
photograph by Lewis Morley
flyer
21 x 18.5 cm TE055

*The sixties*, David Mellor &
Laurent Gervereau (eds),
Philip Wilson, London 1997
photograph by Lewis Morley
book, pp 12–13
28.9 x 26 cm TE042

# Biography

## 1925
Born 16 June to a Chinese mother and an English father, in Hong Kong.

## 1940
First visit to Australia, then back to Hong Kong.

## 1941
Interned by the Japanese at Stanley Internment Camp with his family for the duration of World War II.

## 1945
The Morley family is repatriated to London.

## 1946
Two years' national service with the RAF.

## 1949
First visit to Europe. Begins three years' study at Twickenham Art School, Middlesex.

## 1952
Studies life drawing at Académie La Grande Chaumière, Paris.

## 1954
Marries Patricia Clifford.

## 1957
Lewis Morley Junior is born. First photographs published – a six-page profile in Norman Hall's *Photography* magazine titled 'Lewis Morley, painter/photographer'.

## 1958
First photograph published in *Tatler*, where he becomes a regular. Morley takes up photography full-time.

## 1959
Lindsay Anderson invites Morley to try his hand at theatre photography by working on rehearsal photographs of *Sergeant Musgrave's dance*.

## 1960
Anderson invites Morley to photograph *Billy Liar* with the young Albert Finney for front-of-house. Over the next 10 years Morley photographs over 100 West End productions and dramatically changes the look of front-of-house photography.

## 1961
Photographs *Beyond the fringe*. Becomes friends with Peter Cook, who offers him studio space above his satirical club The Establishment. Morley becomes resident photographer for the club's revues and for *Private Eye*. Photographs Barry Humphries for The Establishment, and so begins a long friendship. Takes the first published photographs of Jean Shrimpton for a fashion feature in *Go!*.

## 1962
West End productions include photographs of young actors at the threshold of their careers: Susannah York, Tom Courtney, Michael Caine, Maggie Smith, Anthony Hopkins, Nicol Williamson and John Hurt, among many others. First solo show at Kodak Gallery, Regent Street. Photographs David Frost and *That was the week that was* for Ned Sherrin, and other Ned Sherrin productions for BBC TV (1962–64). First visit to New York.

## 1963
At the height of the Profumo scandal Morley photographs Christine Keeler for a film that is never made. Photographs many commercials for televison – Blue Band margarine and Kellogg's cornflakes to name a few.

## 1964
Extensive fashion and style work for English newspapers, with Morley often utilising 'non-models' like Susannah York, Bobby Moore and Charlotte Rampling.

## 1965
Directs an extended film clip (now lost) of the Yardbirds performing as a promotion for their first US tour. *Lewis Morley: the reluctant photographer* is shot by Pathé Pictorial in the Lewis Morley Studios. The first photographs of Twiggy are published, taken by Morley for *London Life*.

## 1971

Emigrates to Australia with his family and finds extensive work with style magazines, often working in colour. His work appears in *Belle* from the magazine's inception until the mid 1980s (Morley photographed 33 of the first 75 *Belle* covers). Works with Babette Hayes and for magazines such as *Pol* and *Dolly*. Exhibits photography and mixed-media assemblages regularly in Sydney through the 1970s, 80s and 90s.

## 1978

Commissioned to participate with five other photographers (Mark Johnson, Jon Rhodes, Sandy Edwards, Graham McCarter, Micky Allan) in the CSR Centenary Photography Project.

## 1987

Morley sells his studio.

## 1989

His retrospective at the National Portrait Gallery, London, commences during the release of the film *Scandal* – on Keeler and Profumo.

## 1992

Publishes his autobiography *Black and white lies*, with an introduction by Barry Humphries.

## 1993

*Observer Magazine* publishes a nine-page cover feature on 'The man who shot the sixties'. Included in the exhibition *The sixties art scene in London* at the Barbican Art Gallery, London. The State Library of New South Wales hosts a retrospective of his work, *Right time, right place*.

## 1999

Appears in the Contemporary Australian Photographers series of publications. The Royal National Theatre, London, holds an exhibition *Caught in the act: the theatre photography of Lewis Morley*.

## 2003

*Lewis Morley, photographer*, a documentary film on his working life, is produced as a DVD to coincide with his retrospective *Myself and eye* at the National Portrait Gallery, Canberra. Included in *Pol: portrait of a generation* at the National Portrait Gallery, Canberra.

## 2004

Included in *Art & the 60s: this was tomorrow*, Tate Britain, London, and international tour.

## 2005

National Gallery of Australia, Canberra, honours Morley's 80th birthday. Morley is included in *A question of identity: self-portrait photographs 1855–2000*, at the National Portrait Gallery, London.

## Collections

### Australian

Art Gallery of New South Wales, Sydney
Monash Gallery of Art, Melbourne
Museum of Contemporary Art, Sydney
National Gallery of Australia, Canberra
National Portrait Gallery, Canberra
St Vincent's Hospital, Sydney
State Library of New South Wales, Sydney
The American Club, Sydney
Victorian Arts Centre Trust, Melbourne
Westmead Children's Hospital, Sydney

### International

ADC Blue Print, London
Arena Performing Arts Library, London
Chelsea Arts Club, London
Los Angeles County Museum of Art, Los Angeles
National Portrait Gallery, London
Theatre Museum, London
Victoria & Albert Museum, London
Wilson Centre for Photography, London

# Bibliography

Cook, P & Moore, D. *Dud and Pete: the Dagenham dialogues*, Methuen, London 1971

Donleavey, J P. *The plays of J P Donleavey*, Delacorte, New York 1972

Ettinger, S. 'Lewis Morley', *Black + White Magazine, The Masters* Volume 3, Sydney, pp 22–33

Fulton, M. *My very special cookbook*, Octopus Books, Sydney 1980

Godden, C (ed). *CSR Pyrmont refinery centenary 1978 photography project*, Australian Centre for Photography, Sydney 1978, pp 34–41

Hall, N. 'Lewis Morley: painter/photographer', *Photography* Nov 1957, pp 30–35

Hall, N (ed). *Photography Year Book 1960*, Photography, London 1960, p 46

Hall, N (ed). *Photography Year Book 1963*, Photography, London 1963, p 105

Hayes, B. *Design for living in Australia*, Hodder & Stoughton, Sydney 1978

Keaney, M. *Lewis Morley: myself and eye*, National Portrait Gallery, Canberra 2003

Mellor, D. *The sixties art scene in London*, Phaidon, London 1993

Mellor, D & Gervereau, L. *The sixties: Britain & France 1962–1973*, Philip Wilson, London 1997

Morley, L. *Lewis Morley, Contemporary photographers: 4*, Australia, WriteLight, Sydney 1998

Morley, L. *Black and white lies: self exposures: some long, some short, some indecent*, Collins/Angus & Robertson, Sydney 1992

Pepper, T & Mellor, D. *Lewis Morley: photographer of the sixties*, National Portrait Gallery publications, London 1989

Rideal, L. *National Portrait Gallery insights: self-portraits*, National Portrait Gallery, London 2005, pp 42–43

Rogers, M. *Camera portraits: photographs from the National Portrait Gallery 1839–1989*, National Portrait Gallery publications, London 1989, p 280

Rushton, W. *How to play football*, M & J Hobbs, London 1968

Sayers, A & McFarlane. R. *Pol: portrait of a generation*, National Portrait Gallery, Canberra 2003

Stephens, C & Stout, K. *Art & the 60s: this was tomorrow*, Tate Britain, London 2004, pp 74–78

Waterlow, N. *Larrikins in London: an Australian presence in 1960s London*, College of Fine Arts, UNSW, Sydney 2003, pp 80–81

*Right time, right place: Lewis Morley, photographs from 1960–1992*, State Library NSW, Sydney 1993

Issues of *Tatler* 1958–1964, *Go!* 1961, *She* late 1950s–1967, *Dolly* 1972–c1980, *Pol* 1972–c1980, *Belle* 1974–1987

## Interviews & broadcasts

*Lewis Morley: the reluctant photographer* Pathé Pictorial Film, 1965

Today, Channel Nine, 20 July 2002

*Fame, fashion and photography: the real blow up*, BBC2 TV, 2002

George Negus Tonight, ABC TV, 23 April 2003

ABC Radio National, with Julie Copeland, 4 Jan 2004

*Photographer: Lewis Morley*, ABC TV, 29 Feb 2004 (Tom Thompson & John Mandelburg documentary)

PM program, ABC Radio National, 5 Aug 2004

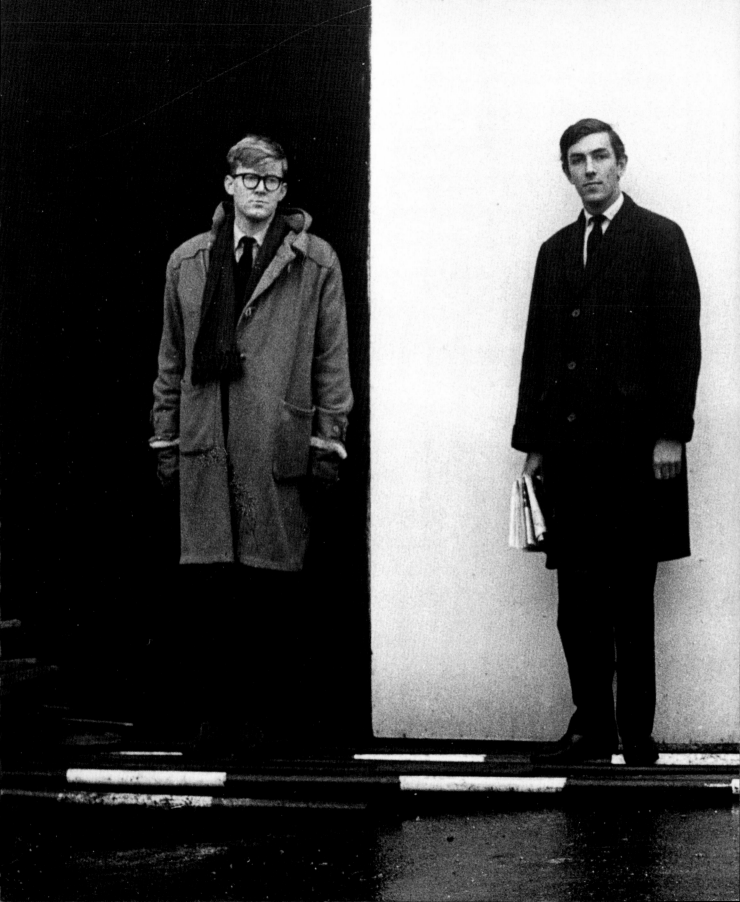

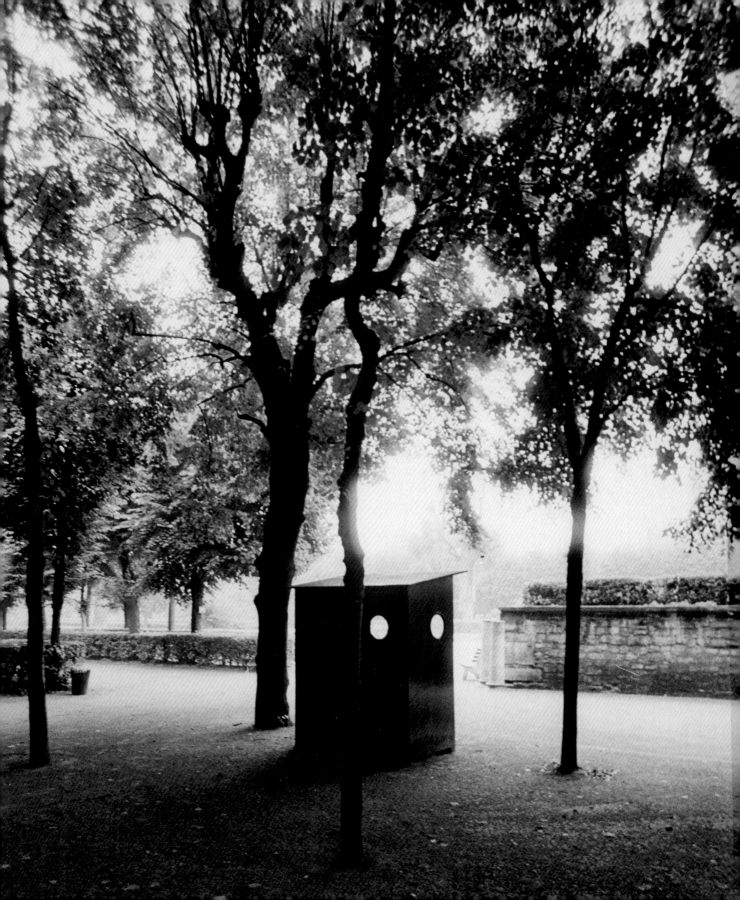